ABSTRACT ART
painting

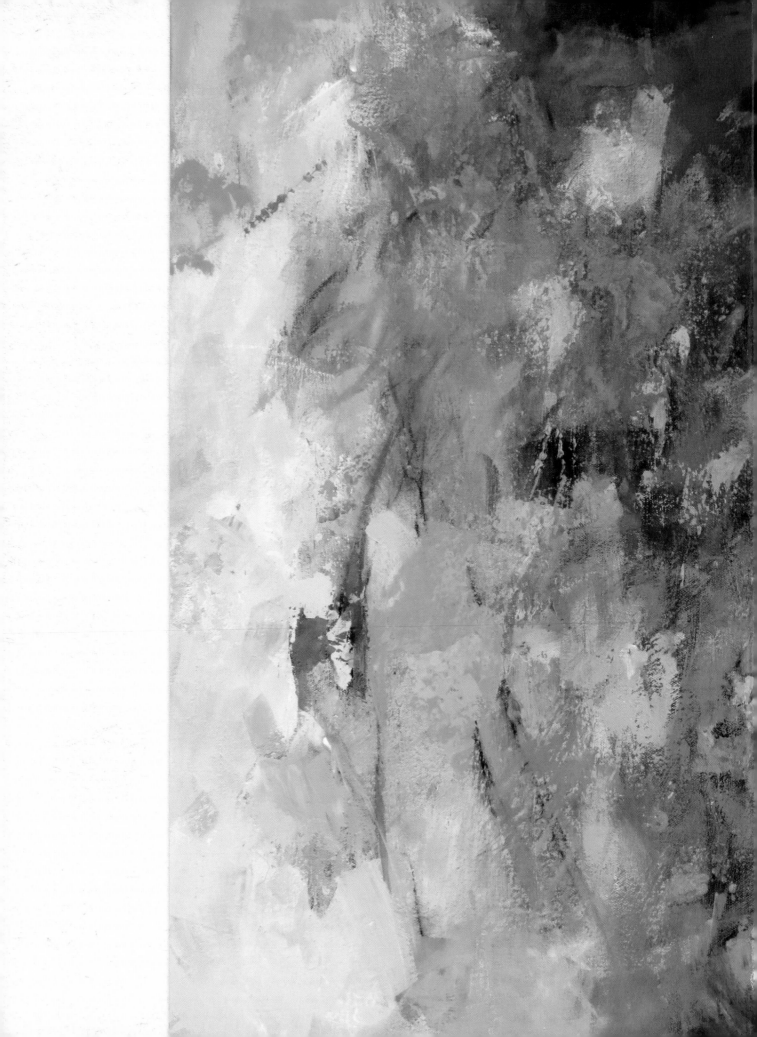

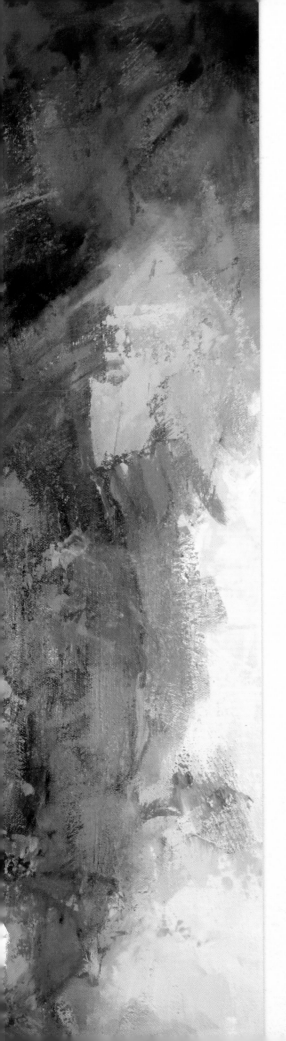

abstract art
PAINTING

EXPRESSIONS IN
MIXED MEDIA

Debora Stewart

NORTH LIGHT BOOKS
Cincinnati, OH
www.artistsnetwork.com

CONTENTS

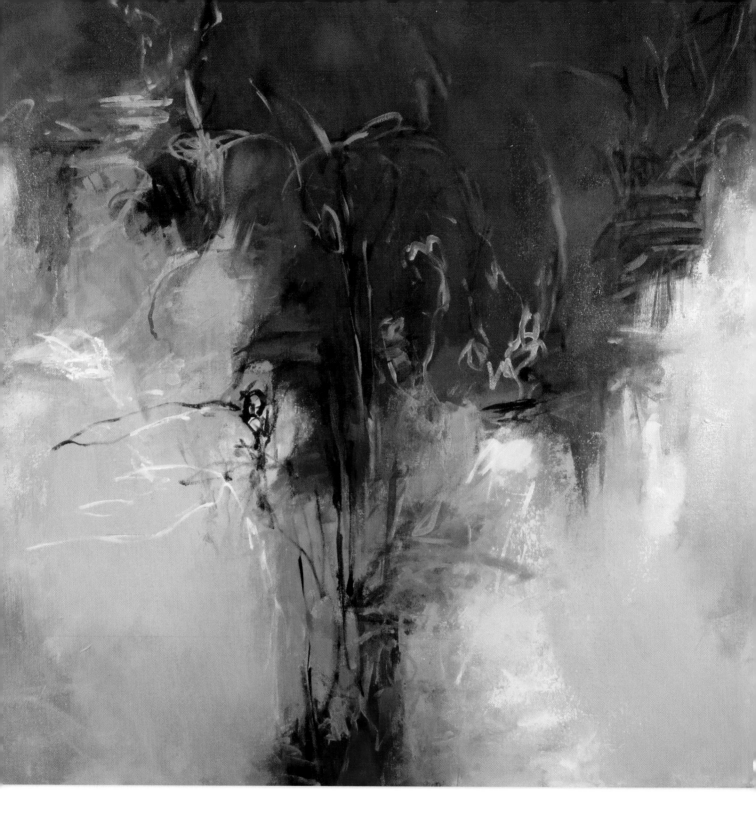

" I found I could say things with color and shapes that I couldn't say any other way—things I had no words for.

—GEORGIA O'KEEFFE

Sign up for our free newsletter at www.ArtistsNetwork.com.

Preparing to see Abstractly

Early in my college years, I had a fascination with abstraction. After a college visit to the Art Institute of Chicago my instructor asked which work appealed to me the most? I replied it was a large black-and-white painting by Franz Kline. It was nothing like the way I drew or painted at that time. She then told me that most abstract artists know the fundamentals of drawing and that I needed to focus on that. I took her advice and devoted myself to working realistically.

I dedicated myself to drawing the human form. I loved life-drawing classes. I also drew and painted portraits of friends as well as many self-portraits. I became proficient at drawing, and many of the marks I made during those life-drawing classes come through in my work today.

My current journey into abstraction came later as the result of feeling stuck and frustrated. I knew that I could take a photograph and draw or paint what I saw. I wanted more and I wanted something different, but what? I began to do much soul-searching. Which artists did I like and why? What drew me to art that I liked? I found that abstract work had the biggest impression on me. I had tried many different mediums in my life from printmaking to oil painting and ceramics to drawing, pastel and acrylics. I loved drawing the most. I loved the act of making marks on paper because I enjoyed the tactile feel of drawing materials. I devoted myself to drawing and began exploring abstraction with drawing materials.

I began to cut up photos I had taken of plants and flowers, and I used them to draw small sections. I discovered that I could find abstraction within realism. I began to experiment, I read books and I attended my first workshop on intuitive drawing. Working abstractly was exciting and I no longer felt stuck. Possibilities began to open up to me. Pastel became my passion and I started to work with it exclusively. I ventured out, entered some competitions, and was excited and surprised that my work was accepted.

Abstraction helped me break out of my comfort zone. I have always believed that art helps us pave the way for changes in our lives; my art has done that for me. Abstraction for me is more than a technique. Abstraction is a state of mind.

In this book, I'll be sharing my personal process. I discovered many things through years of trial and error. I took what I learned from creating abstract pastels and applied it to my acrylic paintings.

Here you will learn how to cultivate your own ideas for abstract images. You will generate ideas using source materials like photographs and drawings. You will take these further by creating small color studies. You will explore the use of color theory in abstraction. You will realize that the elements of art are just as important in abstraction. You will learn to use underpainting to bring structure and depth to your work. You will learn how to use various mediums to bring texture to your work. You will begin to understand how to work in a series and how this can help in the development of your personal style.

This book will help you see that working abstractly does not have to be the mystery that so many think it is.

Preparing to Paint

This chapter covers the materials we'll use the most throughout this book. I continually experiment with and combine materials. Underpainting with fluid acrylics led me to begin painting on canvas. I often use the materials listed here interchangeably. I draw on canvas with charcoal and hard pastels. I use acrylics as underpaintings for my pastels. My pastel paintings may have some materials from my acrylic paintings, but they are primarily pastel works. My acrylic paintings may have some traces of pastel markings, but they are, in the end, acrylic paintings.

> " With abstract art I can create in the moment. No preconceived ideas. I just put some color on the canvas and keep going.
> —PEGGY GUICHU

Pastels

SOFT PASTELS

There are many varieties of soft pastels. Soft pastels are not the same as oil pastels. A soft pastel is pure pigment in stick form. If you are new to pastel, begin with a basic set of artist-quality pastels. Include a selection of earth tones and grays for neutral colors. As you become more experienced, you can upgrade to a higher-quality pastel. Some brands manufacture half-stick sets of pastels, which are a good way to begin collecting and experimenting with artist-grade pastels.

I do not recommend using soft pastels on canvas. They do not easily adhere to the surface of canvas. They will not have the same effect on canvas as on paper.

HARD PASTELS

Hard pastels come in square sticks, and you can use them in both pastel and mixed-media works on canvas. Hard pastels help you block in color on a pastel painting. You can also use them as an underpainting and dilute them with rubbing alcohol. You can also use hard pastels on the surface of a canvas to create lines. They come in a wide variety of colors. Start with a few sticks or a basic set.

CHARCOALS

Charcoal comes in many different varieties. Vine charcoal is soft and creates light lines on both paper and canvas. It is useful for creating initial lines for a composition. You can easily wipe it away. Compressed charcoal sticks create heavier and darker marks on the surface. I prefer the heavier and darker mark making of compressed charcoal and use it for both pastel and acrylic paintings. Charcoal pencils create thin lines that you can use to begin a work or at the end to delineate marks on the surface of a work. I use charcoal in underpaintings, and it is seldom evident in a finished work.

PASTEL PENCILS

Pastel pencils are another form of the medium and are related to hard pastels. They are useful in creating linear work and textures.

PANPASTELS

PanPastels are another form of pure pastel. They come in cakes and are applied with an applicator. They provide the artist with the ability to cover a large area with less pastel. PanPastels are also very helpful in underpainting for pastel painting.

Soft pastels

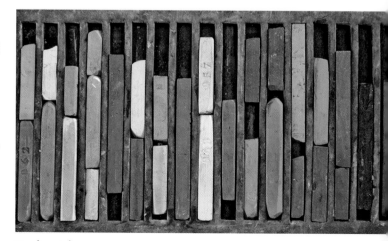

Hard pastels

Paints and Mediums

ACRYLIC PAINTS

Acrylic paints come in a wide variety of colors. You can begin with a basic starter set and build on this. Many different brands of acrylic paints are available to artists. My recommendation is to use artist-quality paints. A basic starter set includes colors such as Cadmium Yellow, Cadmium Red, Ultramarine Blue, Viridian Green, Alizarin Crimson, black and white. I also like to have more earthy colors available such as Yellow Ochre, Yellow Oxide, Oxide Green, Titanium Buff, Burnt Sienna, Raw Umber and Red Oxide.

Heavy-bodied acrylic paints

FLUID ACRYLICS

You can use fluid acrylics on paper or canvas. They are often transparent and are used to create a basic wash of color in the beginning stages of a painting. Fluid acrylics can be used to tint pastel ground, acrylic gels and pastes. I like the intensity and strength of fluid acrylics. I compare their consistency to that of inks. They are not as thick as regular acrylic paints.

Fluid acrylics have a thin consistency and a strong tinting strength, both of which are good for pastel and acrylic underpaintings. Fluid acrylics have a strong tinting strength, which I like for use in acrylic underpaintings. They do not ruin or clog up the texture of sanded paper. You can use them to tint grounds and pastes for canvas and paper. They can be mixed with gels for use on canvas as an underpainting. I use red, orange, green, ochre, yellow, blue and black fluid acrylics for my pastel and acrylic paintings.

Fluid acrylic paints

OIL PAINTS

You can use regular or water-based oil paint on sanded paper for an underpainting for pastel. Use water to dilute the water-based oil paint, but anytime you add water to paper, it may buckle. To prevent the buckling you can weigh down your painted paper with heavy books after applying underpainting. You can also use traditional oil paints on sanded paper. Use a thinner to dilute regular oil paints. I use water-based oil paints because of the ease in cleanup and lower toxicity. Whether you use traditional or water-based, both will take longer to dry compared with fluid acrylics.

GROUNDS AND GELS

A wide variety of grounds, gels and pastes can be used for both pastel and acrylic painting. I experiment with these materials with both pastel and acrylic painting. One product that I use frequently in my work is Golden Acrylic Ground for Pastels. It is a wonderful product and is very versatile. I use it in

Water-based oil paints and watercolor paints

my pastel paintings and have also added it to the surface of acrylic. Adding it to canvas aids me in drawing on the surface of the painting. It dries clear, so it may be applied over an underpainting. It varies in the texture it creates depending on thickness of application. Golden products are carried in most art supply stores.

You can apply molding paste to canvas or boards to create extra texture on the surface of the painting. You can tint molding paste in different colors and apply it directly to your canvas before you begin painting or during the painting process.

Other products can be used in both pastel and acrylic painting to add texture and dimension to paper or canvas. These products include micaceous iron oxide, fine pumice grounds and different gels to build up the surface.

I love to experiment, and I encourage you to try these products to see what they can do for you. We learn from the time we spend experimenting.

FIXATIVES

A variety of fixatives for pastel paintings will not change the color of a finished work. I seldom use fixative on a pastel that is painted on sanded paper. I finish those paintings by using an archival glue and attaching them to an archival backing board. I weigh the pastel down to the glued backing, cover it with glassine paper and weigh it down with books. This weighting with books helps fix the pastel to the surface of the sanded paper. After this process there is very little pastel dust. I do apply a light fixative on pastels that I have created on Rives BFK paper with Golden Ground. I apply a light spray of Lascaux fixative before framing. I have not noticed any color change after application. There are numerous fixatives available, and this also requires research and experimentation to see which one will work for you.

COLORED GESSOS

Gesso now comes in a variety of colors. I often begin my acrylic paintings with colored gesso because it is very helpful in a painting's beginning stages. I use a selection of black, gold, red, ochre, green and blue. I also use colored gesso to paint over an area that I want to rework. Companies making colored gesso include Golden, Daniel Smith and Holbein.

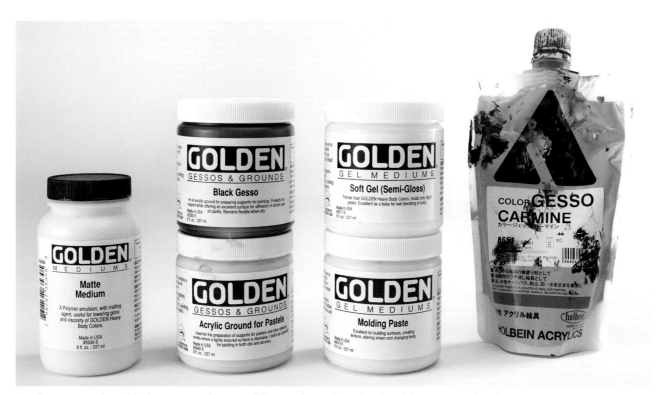

Acrylic matte medium, black gesso, acrylic ground for pastels, acrylic soft gel, molding paste, colored gesso

Surfaces

PAPERS AND BOARDS

There are so many different surfaces for artists to work on. Pastel artists have many choices available, from regular pastel paper to sanded surfaces, prepared board and various grounds. I have used several different surfaces and am always experimenting to find the one that works best for my style. You will need to do the same. Now I prefer working with paper and pastel ground because it suits my style. I have also worked extensively on the sanded papers like Wallis and UART. I recommend trying a wide variety to find the surface that works for you.

CANVASES

In this book I show working on canvas paper and on stretched canvas. I tend to create color studies for paintings on canvas paper or small stretched canvas. Canvases come in a variety of surfaces and profiles. You can purchase a very thin, traditional profile canvas that may be ¾" (19mm) deep. You can also purchase a deeper profile canvas that can be from 1½" to 2" (38mm to 51mm) deep. I prefer working on the deeper gallery wrap canvas that is 1½" (38mm). I am able to carry the painting around the edges or paint the edges a single color. I have found the deeper profile canvases are less likely to warp and are somewhat more sturdy.

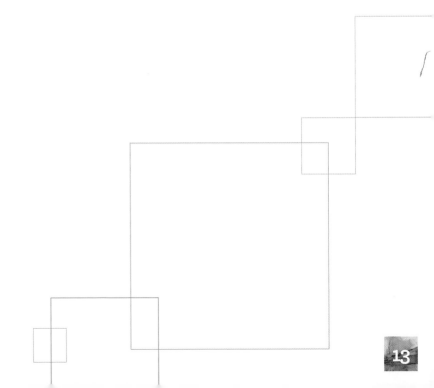

Brushes and Other Tools

BRUSHES AND TOOLS FOR CREATING TEXTURES

I now have a wide selection of brushes and painting tools that I use in acrylic painting. I even have brushes I use with my pastel paintings. I use inexpensive wide brushes from a craft store to apply pastel ground to paper or canvas. Foam brushes from the paint store are used to apply gesso to canvas. Wide, long-handled brushes are used for large acrylic paintings. When I paint large, I like brushes with long handles as they allow me to move away from the painting and have a broader sweep of motion with my arm. I use other tools to help build texture and apply lines to canvas. I also use larger painting knives to help create different textures on canvas. I am always experimenting with different ways to apply paint and texture.

Assorted flat brushes and long-handled brushes

Assorted small brushes

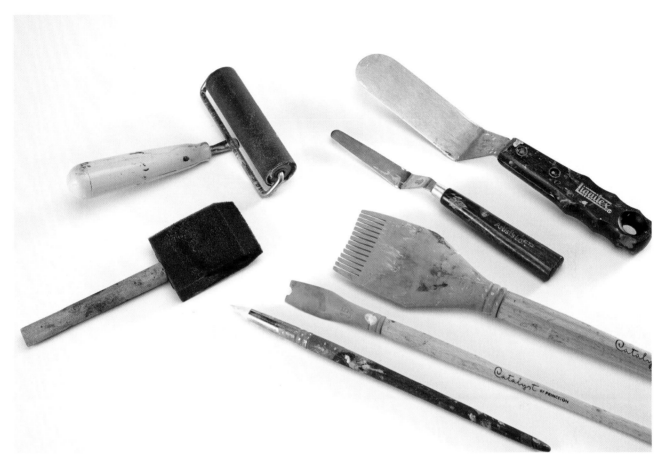

Rubber brayer, foam brush, palette knives, Catalyst blades, paint eraser

EXPERIMENT WITH TOOLS AND MATERIALS

There are many tools and materials that I use in my pastel and acrylic paintings. I encourage you to experiment to see what will work for you and your style. I discover many new tools, materials and ideas from artists' blogs, YouTube videos by artists, magazines for artists, books and online forums. Don't get stuck working the same way. Sometimes changing one thing may be the inspiration you need. My only recommendation is that your tools and materials be quality and archival and that they work together.

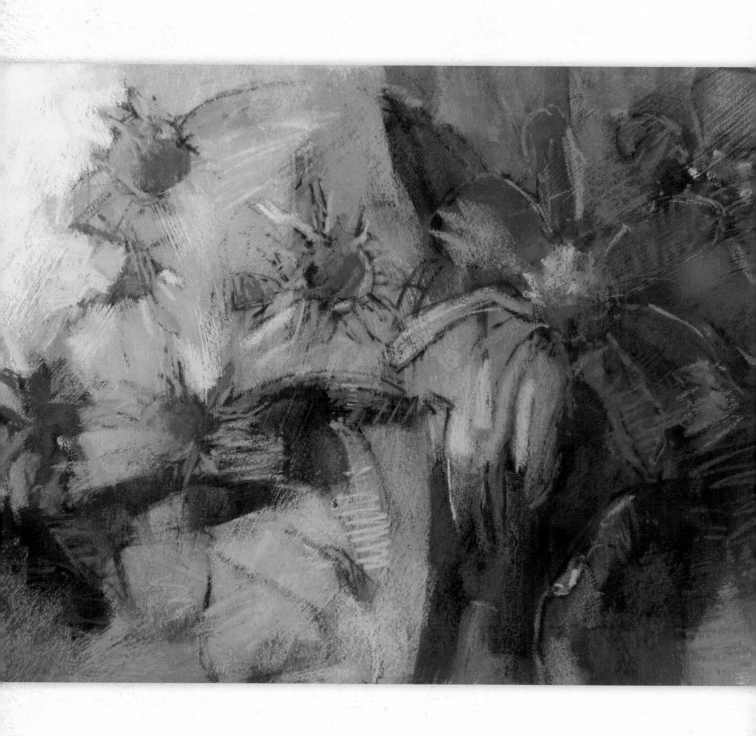

Why AND
How TO **Abstract**

❝ Of all the arts, abstract painting is the most difficult. It demands that you know how to draw well, that you have a heightened sensitivity for composition and for colors, and that you be a true poet. This last is essential.

—WASSILY KANDINSKY

This is a wonderful quote in regards to abstract art. Some mistakenly believe that abstract art is easier than realism. I believe it is very challenging to create a good abstract work of art. Creating a good abstract painting is a goal that I will always work toward. I strive for progress with every work I create. I believe all of the elements and foundations of art are essential in creating abstract works.

I also believe that drawing is fundamentally important. It is a mistake to think that abstract artists don't not know how to draw and that is why they work abstractly. Some may say, "I could do that" when referring to an abstract painting. I have heard this many times, and I realize the person does not really know the process of creation and the background of the artist. An abstraction takes as much planning, thought, skill and mastery of materials as a representational work. When I walk into a museum or a gallery, I am immediately drawn to the abstract works. I find them exciting, fresh and inspiring.

Many representational artists do not know where to start when developing abstract art. Abstraction seems like a mystery to them. After attending my workshop, many artists tell me "Now I know how to start." It often looks more mysterious than it is. I find abstraction simple but very challenging. It should be challenging or it would be easy for anyone to do it. Working abstractly stretches an artist.

So how does one go about creating an abstract work? What is the process an artist goes through? It is as individual as the artist is. The artist's style has probably developed over a long period. Abstraction often grows because of other work the artist has created. It may grow and develop because of life experience or a different way of looking at things. Working abstractly is as much about the individual as it is about the results that show up on the canvas or paper. There is so much more to it than learning a formula or technique.

Some want to know how long it takes to create an abstraction. The actual work may take two hours or two weeks, but the development and synthesizing of ideas and technique may take a very long time.

How Do You Create Abstract Art?

Working abstractly seems like a mystery to those who want to but do not know quite how to begin. While there are many different ways to create them, abstract paintings fall into two basic types. One type is nonobjective, which involves using shapes, colors, line and other elements of art to create an abstract composition. Another type, figurative abstraction, includes abstracted landscapes, figures, still life or animals. I usually tell artists to start where they are to create an abstraction. If they are coming from the point of view of a landscape painter, they can start there. To abstract the landscape they would eliminate detail and bring the landscape to its essential and basic structural shapes. They might also add intuitive and personal color choices instead of realistic colors.

The basic way to create abstraction is to simplify down to essential shapes. Eliminate the details in a photograph or drawing. Look at the same thing in a different way. Bring emotion and spontaneity to your work. Utilize the elements of art just as much as in realism. Be open, experiment, change directions, and try new materials and ways of working. Give up control over outcomes; have a plan but be willing to change it.

ABSTRACTION IS A NEW WAY OF SEEING

Abstraction is a state of mind and another way of seeing the world around us. Reality often serves as the starting point. Instead of looking at the whole scene or object, change your focus and look closer to see something small. Instead of looking at the tree, you might see the shadows of leaves on the wall. Instead of looking at the stream, see the reflections of light on the surface of the water. See the pattern of sunlight as it moves through the trees.

Some artists use the elements of a landscape, simplify the scene to its basic elements and choose colors based on emotion or intuition. Reality may continue to serve as your inspiration. When you see Georgia O'Keeffe's abstractions, you can see how many of her works began with a realistic viewpoint. Abstraction is a personal expression. It should reflect the passions of the artist in the same way as realistic art.

ABSTRACT WHAT YOU KNOW

How do you begin to develop ideas for paintings? You can begin by abstracting what you already know. You may be a landscape artist who wishes to work more abstractly. How do you go about this? You begin by changing your focus. Your abstract expression of the landscape may become an emotional reaction to the environment. Choose your colors based on this reaction. Use lines differently to express your response to the landscape. Choose a small portion of the landscape to focus on. You are inspired by the same impression or concept, but you express it in your own way.

Abstraction provides freedom but is also very challenging. It should be exciting. Working abstractly is much more than marks on paper or splashes of paint on a canvas. Abstraction contains the same elements of art as representational work but is conveyed in a different manner. The most challenging aspect of working abstractly is finding your own personal voice and style. This is something that can only come with creating the work and devoting time to improving your skill. I do hope the information I am giving you in this book will help you on your journey to abstraction.

ASK "WHAT IF" QUESTIONS

In abstraction you will always ask yourself "what if" questions. What if I start my pastel painting with a bright red underpainting? What if I add texture to my acrylic painting? What if I begin with a 4" (10cm) brush? What if I apply my paint with a roller? What if I put pastel on my canvas? You should always be open to experimentation and trying new ways of working. Experimentation is an important part of discovery and of abstraction. No one can give you an exact recipe for an abstract painting. You can be given direction but there are many different ways to get there.

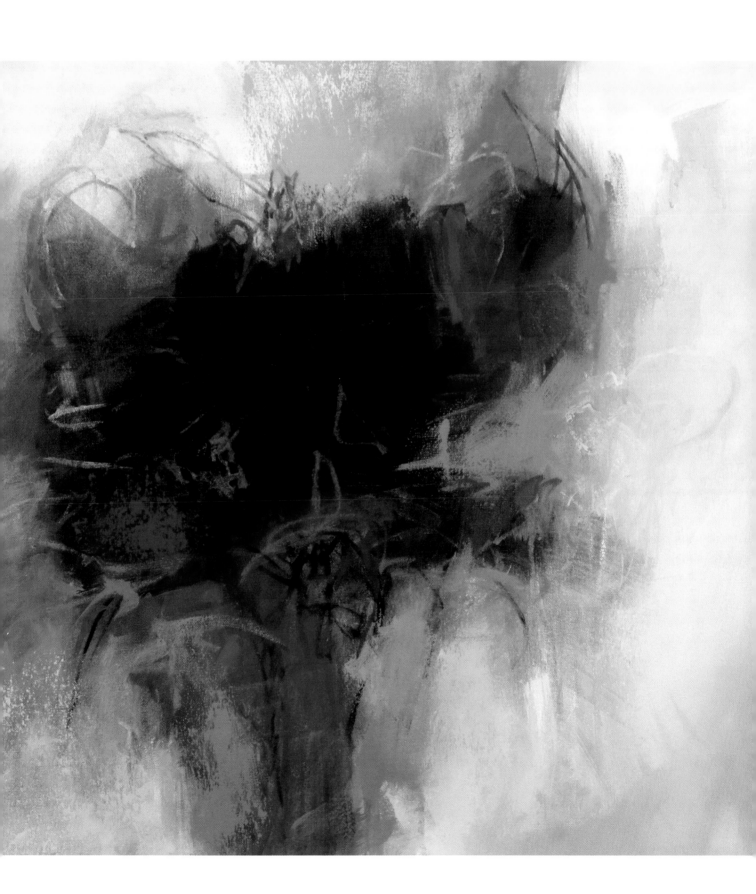

What Are the Benefits of Working Abstractly?

There are varied reasons for wanting to work abstractly. Of course, it does not have to be your primary means of expression. You may want to venture out into abstraction for fun but plan to return to working realistically. Will it help your realistic work? I believe it will help you loosen up, work more expressively and approach your realistic work in a different manner. In workshops, I have had realistic artists tell me that they did not realize the same foundations apply to abstract art as they do to realistic works. Abstract art uses the same basic elements and foundations of art but in a different way. You are still assessing your work for value, balance, variety, focal point, movement and composition.

Working abstractly allows expressiveness. You are able to tap into your deeper self and bring feeling to your work. Abstraction involves using your intuition to help you choose the colors and marks you will create on your painting. Abstraction might lead you to expressing spirituality or a deeper meaning in your work. Abstraction can be inspirational and help you to see beyond yourself. It can be playful and full of movement. It can be expansive and help you open up to new possibilities. Working abstractly requires thoughtfulness as you choose which marks and colors to make in response to the ones you have already made. Abstraction is personal and unique for the individual artist. The artist's individual marks and expression always come out through her work. Abstraction is freedom of expression.

Abstraction is a Personal Journey

Abstraction is a personal journey. You may begin because you admire the work of another, but their way of working will not be your way. You can take what you learn from others and then make it your own. I am sharing my personal way of creating pastels and paintings with you, but you will take this information and bring your own experience to it. You will create abstractions that are personal to you. You cannot help but bring your own life experiences into your work. It should be a personal expression. Our life experiences always come through in the energy of the brushstrokes and mark making, our color choices, compositions and what inspires the works. Sometimes we have to get out of the way and just allow it to come through our work.

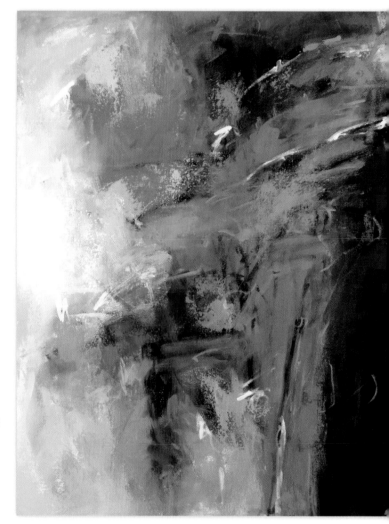

YOUR OWN ROAD MAP WILL GET YOU THERE

In realistic work, you have a reference to guide your drawing or painting. You may diverge from this reference and add your own personal touches. You still have something in front of you to guide your decisions. You can see in your photograph which area of the landscape should be lighter or darker. You have a reference to help guide you. In abstraction, you do not have a road map to guide you on your way as you might when you are using a photograph to render a realistic landscape. You begin to rely on internal markers to guide your way. You may begin with a photo or section of a photo but soon put it away. You respond to the work in front of you. You put down a mark and it calls for another. You choose a color you feel is beautiful. You choose another because you feel the impulse to pick it up and use it. You learn to trust internal cues, and your work becomes more of a dialogue with your creation. You communicate with the paper or canvas. You begin to develop intuition and expressiveness. Intuition develops over time and through experience.

Exploring and Reflecting

Do some personal reflection on what appeals to you. Look at the work of other artists who work abstractly. Record in a journal or sketchbook what appeals to you about their work. Do you see textural elements you like? Is it their use of brilliant color? Do you like how they abstract the landscape or some other aspect of nature? What is it about the image that draws you in? How can you experiment with these elements in your own work? Can you create work that is more vibrant or has stronger values?

Look at your own work. What do you like about it? How can you abstract what you already know? If you are working with the landscape, how can you abstract this? Are you drawn to trees, streams or mountains?

What do you find beautiful? Record some of the things you find beautiful in a journal or sketchbook. What in life and your surroundings makes an impression on you?

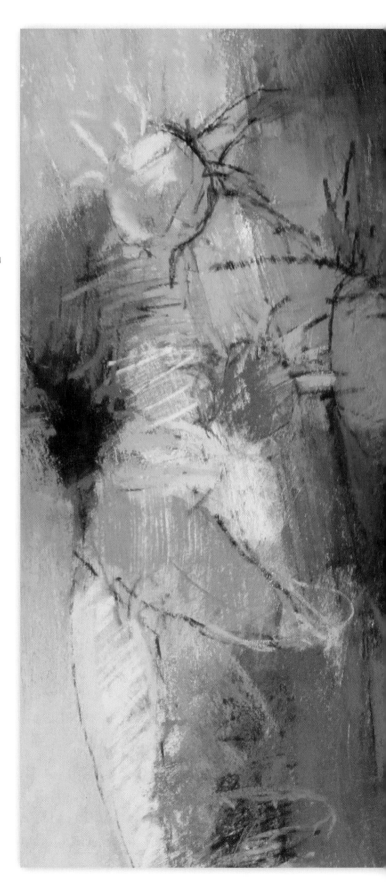

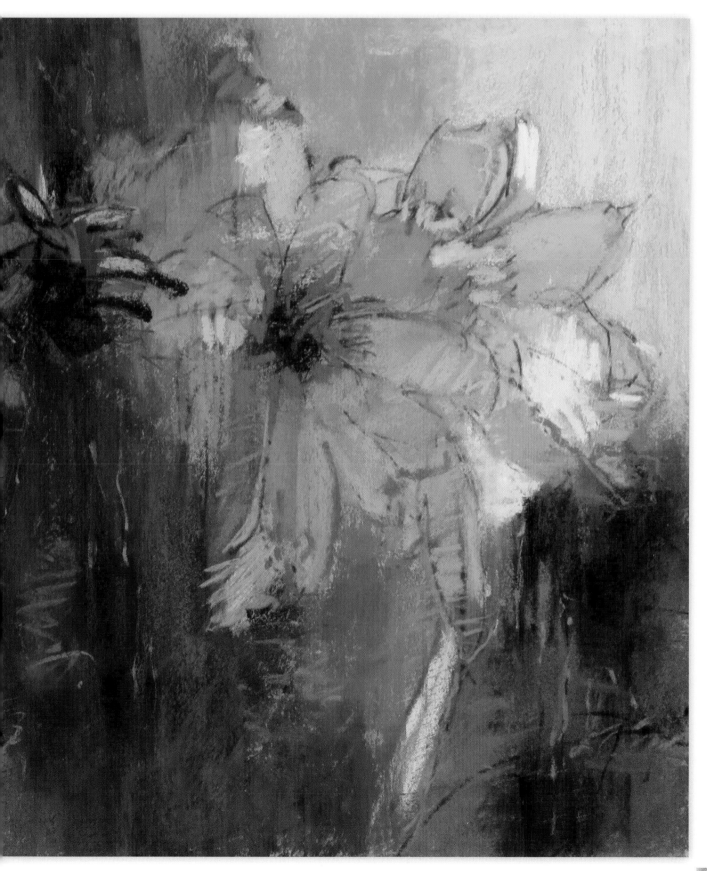

Loosening UP

" Abstraction demands more from me than realism. Instead of reproducing something outside of me, now I go inward and use everything I've learned thus far in my life.

—SUSAN AVISHAI

I love this quote, which says a lot about the way I feel about working abstractly. Abstraction is much more than a technique. It comes from a deeper place and brings together all of life's experiences. I was searching for something beyond realism and wanted to achieve something deeper and more personal in my art. I entered a period of much introspection and searching. If I was going to spend my time creating artwork, I wanted it to be exciting, authentic, true and personal. I began experimenting and broke away from working realistically. I often felt lost and was unsure about what I was doing. I began experimenting with different ways to draw and utilize materials.

The following pages are a compilation of ideas and techniques I tried and found helpful.

Working Intuitively

How do you move from working realistically to working abstractly? Working abstractly can be an extension of realistic work, or it can be a very divergent path. You need to look at your own work in a different way. You need to let go of control and open yourself up to new possibilities. You also need to take time to experiment with mark making, application methods and compositions. In abstraction you react to the surface you are working with and allow it tell you where to go. You begin to work intuitively.

LETTING GO OF THE OUTCOME

You might like to begin a work and know beforehand where it is headed. You want to take a photograph and copy what you see on a sheet of paper or canvas. If all goes well you know you will be able to display and frame the work. Maybe you will give it as a gift to someone close. Having a plan and expecting an outcome makes things predictable.

Abstraction can be an entirely different process. You start out to create a horizontal rectangular work and end up with a vertical work. You have an idea in mind and end up somewhere else. In abstraction you must be open to change and surprise along the way. You must let go of outcomes. You do need to have a plan and direction for what you hope to accomplish, but you also need to be open to changing direction. I like to think of it as "getting out of my own way." I know that is hard to grasp, but that is how I think of it. On my best days, I start out with a vague plan of composition, color and size. I begin to work and I am open to things moving in a different direction. This is what is exciting to me about abstraction. You get unexpected results that are often better than your original plan.

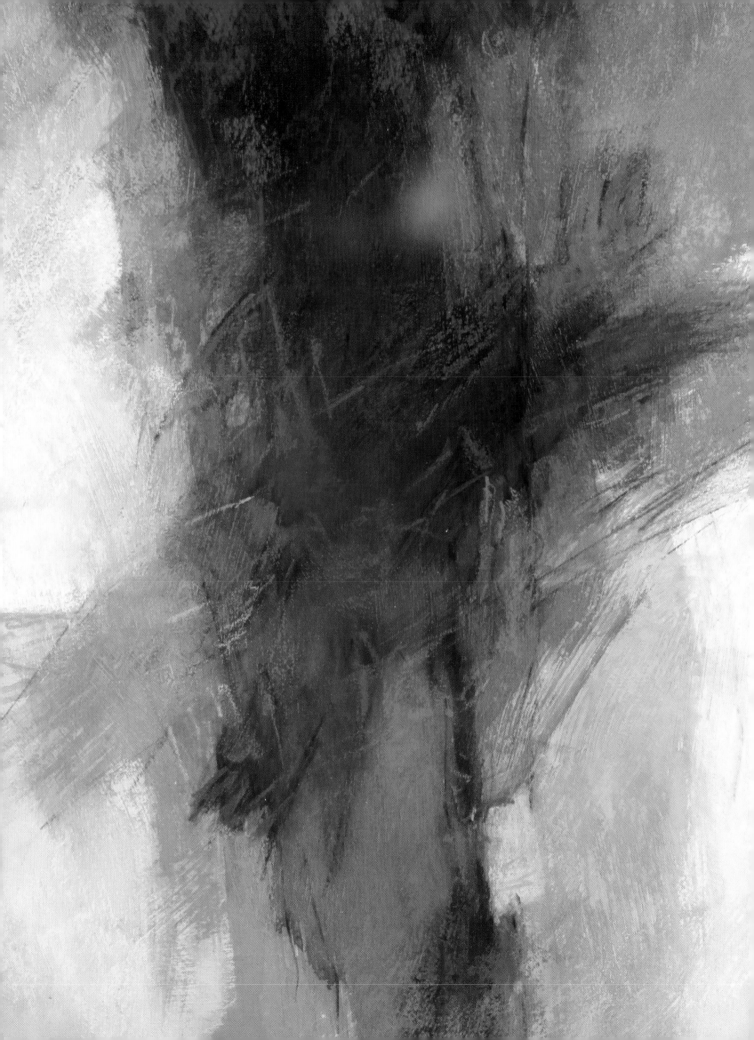

EXPERIMENTING AND PLAYING

In order to go with the unexpected, you need to take time to play. It does not matter what materials you use as long as you take time to experiment. This helps you let go of outcomes and learn to trust your intuition. You have a different mindset when your only intention is to play. You are free to explore and let things happen. You know you may throw whatever you do in the trash, so you do not care about results. I believe that in the beginning it is just as important to take time to experiment as it is to have a plan. It is through this time of experimentation that a lot of learning takes place. You have to allow yourself to work with a sense of abandon and work without thought of outcomes because being too concerned with outcomes can hinder your progress. You can get in your own way if you are too concerned with what you are going to produce. It is often through this period of play that you discover a new way of working with a material. You find your own personal style through experimentation. There is a fine line between deciding on a direction for your painting and allowing it to take on a life of its own.

Experimentation and play also help you change from one daily activity to the time you set aside to be creative. If you have the demands of another career, this is even more important. It is similar to meditation. You enter a new frame of mind and are able to switch gears. It is like doing warm-ups for your creativity. It can be very challenging to just jump in and create. You have to take some time to enter into the right frame of mind. Play and experimentation help you in those times when you feel stuck and lack direction in your art. It is important to just "do something" to get the creative juices flowing. Waiting for inspiration rarely works. It is important to get busy doing something, and then the inspiration comes later.

Sometimes trying different materials opens up new possibilities. Paint random shapes and lines with watercolors. Allow the paints to flow together. Use large sheets of paper and paint or draw to music. Cut or tear pieces of colored paper and arrange them in different ways to generate ideas. Try using a brayer instead of a brush to apply paint. Look for other ways to apply paint to paper or canvas. Take time to work with different materials in a different manner. Time that you take to experiment and play helps you discover new and personal ways of expression.

SPEND SOME TIME DRAWING

An early instructor of mine told me, "Most abstract artists know how to draw." She also told me that if I wanted to work abstractly I needed to focus on the fundamentals. Now that I have been working abstractly for a while, her words come back to me and I realize how right she was. Many ideas for my first abstractions came from drawing. I think when we are in the act of drawing something real, we truly enter a type of meditative state of mind. We open ourselves up to new ideas and we slow ourselves down. It is a definite shift in thinking. We may become one with the plant or flower we are drawing. We may see abstractions in our realistic works. It is very important to spend time drawing as that is from where many of our ideas flow. Take time, go outside with some large paper and charcoal, do some blind contour drawing of what you see. Draw something organic like plants or flowers. You may find yourself using these in your abstractions. These drawings can be wonderful source materials later on.

A blind contour drawing is where you look at the object and not your paper. The objective is to be observant. You follow the curves of a shape, the space around the object, the folds of fabric, the leaves or petals. You imagine your pencil is touching what you are looking at. As you move your eye across the folds of fabric, your pencil also moves. You do not concern yourself with portraying an object or figure realistically. Many wonderful lines and sections of these drawings can be used in an abstraction. You also begin to look inward for inspiration.

Drawing with Your Nondominant Hand

One great way to loosen up is to try drawing or painting with your nondominant hand. If you have never tried this, it might be time you did. This is another good way to give up control. You may even be more creative and like the results. It is an excellent way to turn on your creativity because you are lessening the control you feel. Use large paper and charcoal and perhaps inexpensive paints and/or pastels for these exercises. What do you draw? You can draw to music, make random marks or draw something from life. Are you happy with the results? How can you bring some of this looseness into your work?

What You Need

- charcoal
- newsprint

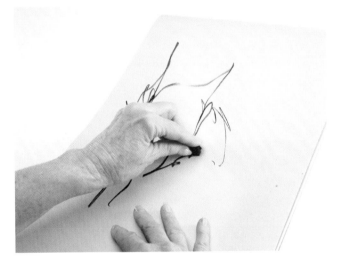

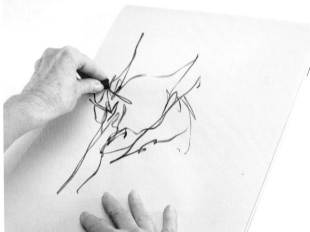

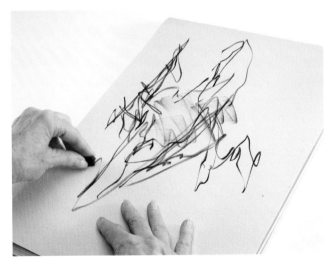

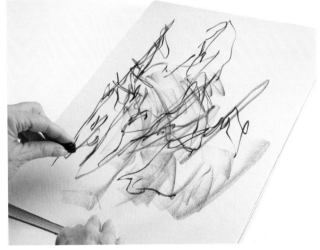

Try drawing with your nondominant hand. This will help you loosen up and work more expressively. This is purely an exercise, and you should not be concerned with creating a work of art. Make marks freely with your charcoal.

Drawing to Music

Music has a way of helping us switch gears and loosen up. You may like to work to soft relaxing music because it helps you relax and lighten your mood. Switch gears and try some different music. Maybe you need to increase the volume and your activity. Put a large piece of paper on your easel, get out charcoal or paint and create marks to the music. Charcoal is great for this because it is immediate. You do not have to waste time mixing paint or looking for the right pastel. React to the music with lines and marks. Do not think about what you are doing. Just do. Allow the music to influence your movements and mark making. You are not trying to create anything. This will help you work more intuitively. Just make random marks, lines, dashes or dots to the music. If you are using paint, use the same technique and try using one or two colors. This exercise will help you loosen up and switch gears. You may also be able to use the results later on for a painting.

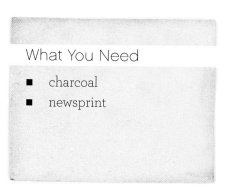

What You Need

- charcoal
- newsprint

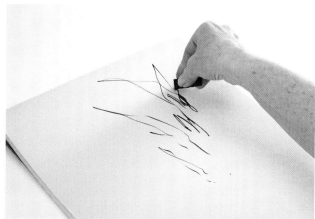

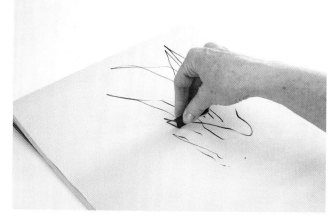

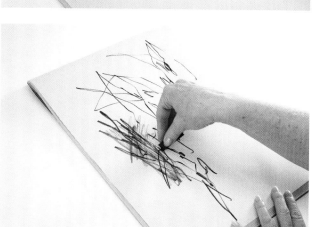

Choose music that you like. You can choose soft, flowing music or energetic music. Let the music inspire your mark making. Try to let the music express itself through lines and marks. Do not be concerned with outcome, only with expression.

Finding Your Natural Mark

Artists have unique and individual marks. How do you discover yours? You can often recognize the work of an artist by their personal mark. Their mark making is as unique as their signature. Close your eyes and make marks on paper with charcoal or paint. Is your natural mark straight, fluid, jagged or soft? Does it dance on the surface of the paper or canvas or does it jab? Is it strong and forceful or is it lyrical and fluid? Your natural mark will result in your work being unique and identifiable whether it is pastel or painting.

What You Need

- charcoal
- newsprint

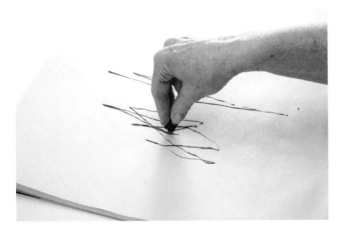

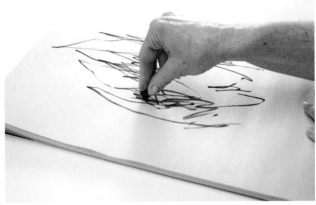

What is your natural mark? Try drawing with your eyes closed. Create marks and lines on paper. Do not be concerned with what it will look like. Drawing with your eyes closed will help you work more intuitively.

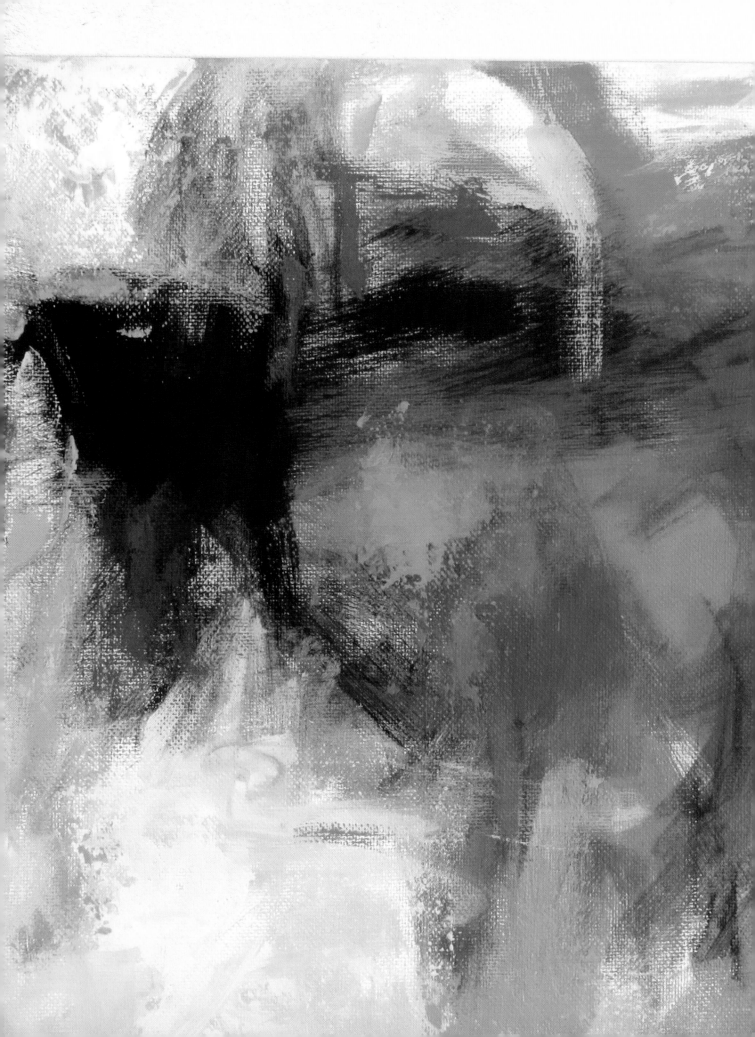

Emotions
AND
Abstractions

❝ The artist is a receptacle for emotions that come from all over the place: from the sky, from the earth, from a scrap of paper, from a passing shape, from a spider's web.

—PABLO PICASSO

Does art express the emotions of the artist? Does art express the inexpressible? Do you feel an emotional reaction when you look at the work of another artist?

You may not intentionally try to express certain emotions through your work, but they do have a way of coming out. Emotions are expressed through the colors you choose and how you go about creating marks on the surface. Should expressing emotions be the sole goal of a work of art? Maybe not, but tapping into emotions can help your work become more expressive. How do you express emotions through drawing or painting? We'll explore two ways in this chapter: mark making and choices of color.

Mark Making and Emotions

Let us begin with mark making. When you look at a drawing, you see a variety of marks. You may see flowing marks and you feel serenity. You may see sharp jagged marks and you think the artist was feeling frenzied or energetic. You may see bold marks that tear across the paper or canvas, and you wonder if the artist was expressing anger or strength. Mark making within a drawing or painting does reflect an emotional state of mind. The state of mind may be conscious or unconscious by the artist. You may not even be aware of how your emotions are affecting your work. We cannot separate ourselves from our emotions because our emotions are what makes us human. Art reflects the totality of the artist.

Working abstractly often results in creating more self-awareness. The essence of who you are comes out in your art. This is natural. When you begin to work intuitively, you are working more from your own personal center. You choose colors intuitively and this may have to do with a feeling state. You may create marks based on your energy level, frame of mind or emotions. Everything affects you. Artists are sensitive to the world around them. I do think art requires us to be self-reflective, and we bring the results of this to our work. Reflection guides your work. Time spent being more aware of what inspires you, colors you are drawn to, artists you love, aspects of your environment that influence you and life events will benefit your artwork.

How can you explore emotions in your own work? Try the following exercises to help you express different states of mind and characteristics. You may even discover possible ideas for works in pastel and painting. They are meant as warm-up exercises and can be done at any time. They may be good to do when you have not worked for a while and need to get back into your studio. They may also be good for you to do if you have a lot on your mind.

Expressive Marks

Take some time to explore various emotions with line and mark making. Get out a few sheets of newsprint or inexpensive paper for this exercise. Here I've used charcoal, but you might wish to use pastel, or black and white paints, along with a long-handled brush.

With line, you can express various emotional states of mind and human characteristics. You do not want to create images in this exercise. You only want to express the emotional state of mind contained in the word. Use a variety of different marks to express the concept behind the word. Use short, long, fluid, jagged, light and dark lines. You may take some time to loosen up first by making any type of random markings on paper.

What You Need

- charcoal
- newsprint

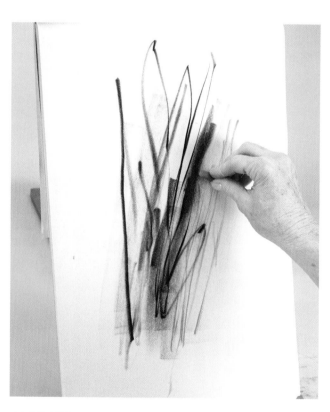

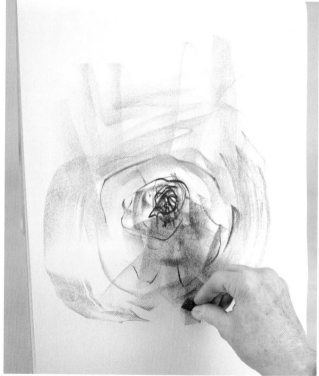

ANGER

Let yourself think about or embody the emotion you want, using colors that emphasize those feelings. With anger I tend to use darker strokes of charcoal with intense reds and blacks in striking motions across the page.

FEAR

Fear evokes timid feelings of insecurity. At first I go with small circles, pulling myself inward. I might branch out with new colors like green and red, but I never stray too far from the inner circle of the canvas.

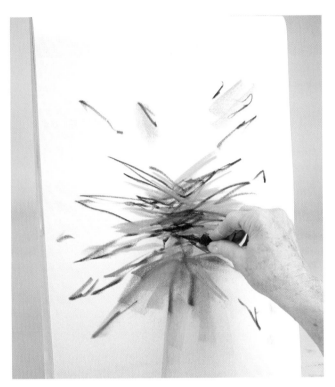

CONFUSION

Using unsure, dark strokes I strike out across the page, always returning to the same initial spot. Using other colors, I highlight the inner sections of my image, not knowing what way to go or what color to use, so I go in all directions with all colors.

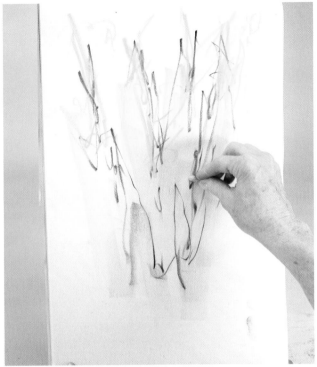

HAPPINESS

My strokes tend to be all over the canvas, venturing out, up and around. I highlight with yellow, letting the glow the feeling makes come onto the page.

LOVE

Using warm colors, I tend to move my charcoal in circular patterns, blending the lines to make it reflect a warm and fuzzy feeling. I darken the middle circles to reflect the intensity of the feeling from the center core of the canvas.

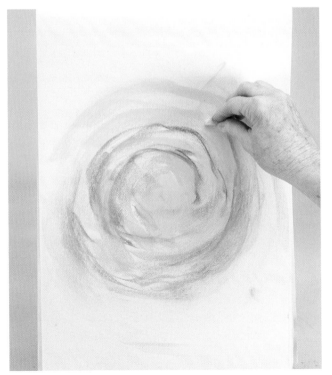

other emotions TO try

Beauty
Exuberance
Joy
Family
Illness
Loneliness
Loss
Serenity
Stress

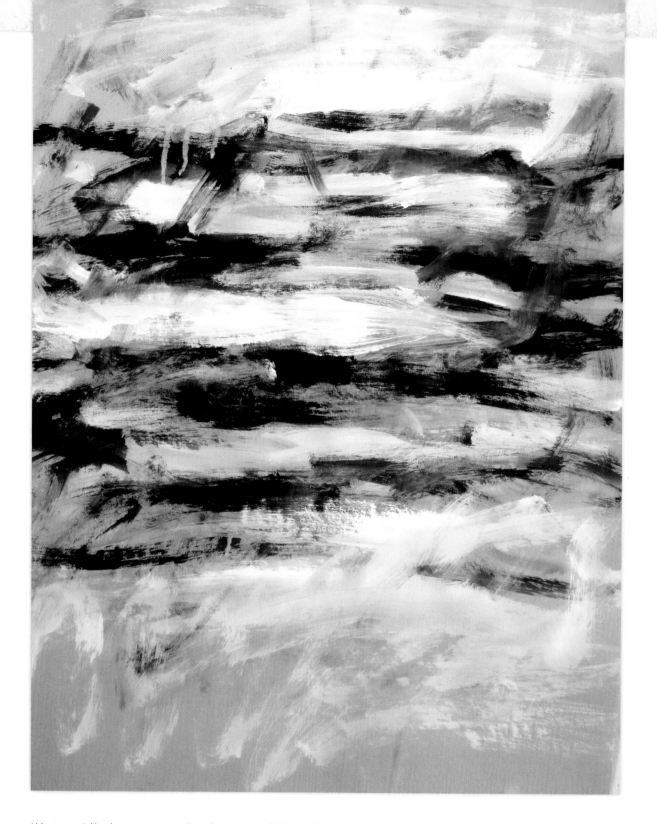

What was it like for you to complete this exercise? Was it difficult and challenging? Was it freeing? What emotions were easiest for you to express in line and mark making? What emotions were most difficult to express?

I have often used this exercise with adolescents in both classroom and counseling settings. They have really enjoyed expressing emotions through art. When this exercise is conducted in a group setting, it is easy to see the universality of our symbolic expression of emotions through art. We can look around and see that many people express anger, serenity, fear and happiness in much the same manner.

How can you use this in your artwork? Look at your mark making from this exercise and see if you can use it to express certain emotions through your abstractions. You may want to create an abstracted seascape that gives the feeling of peace. How did you express peace in your mark-making exercise? Can you incorporate some of the mark making and compositions in your abstracted seascape?

Color and Emotional Impact

Color choices of an artist also create and evoke a certain emotional response. A painting with a primary color of red often displays a sense of power, intensity or anger. I went through a red phase in my own artwork. I could not get enough of red. It started showing up in everything I did. It was not conscious on my part, but I felt a strong attraction to it. A year later, I came to realize that red symbolized power and strength. I needed more power and strength in my life, and this resulted in my use of red.

Repeat the previous exercise now, using the same words, except this time use color to express the emotion. Begin with line, and add color to it as you progress. This is not meant to be a finished artwork or to take much time on your part. There is no right or wrong way to do this exercise. You are letting what is inside come out through line, mark making and color.

Experiment with charcoal, pastel and/or acrylic paints for this exercise. Work small or large depending on your own preference and availability of materials. I recommend using inexpensive paper whether you plan to draw or paint.

You might begin with making marks to represent anger. Your marks are bold and slash across the paper. You now begin to add color with pastel or paints to further your expression.

Choose colors that represent anger to you. Choose two or three to begin. Put marks of color down on paper with pastel or paint.

Go on to the other words to find colors that to you express the emotion or trait.

Continue with other emotions such as joy, fear, sadness, happiness, peace and isolation. Choose any of the words listed as well as words that you think of. The point is not to paint a picture but to create an abstracted representation of the emotion with lines and colors.

Although this is an exercise, you might find it very beneficial. Exercises like this will help you develop intuition. You are drawing on your own internal frame of reference.

Is there a section in one of your works that you might like to replicate in painting or pastel? How can you use this in your own work? Which word or words were the easiest for you to express? Did your creations surprise you? What did you learn about yourself as you worked? Save these; you may want to use them at another time. You may also want to repeat this activity in the future. This exercise helps open channels that may be blocked and is great to add regularly to your practice.

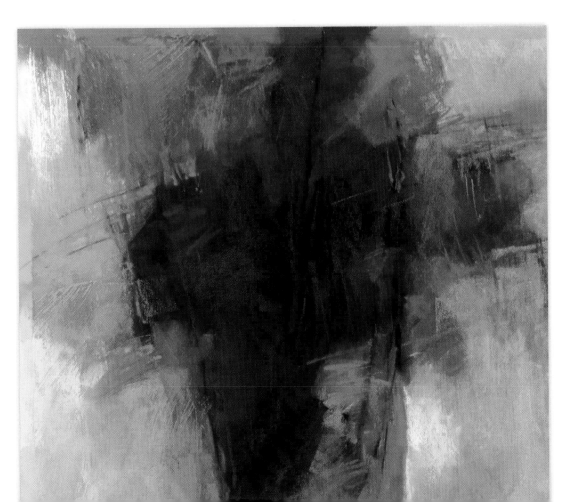

Color Meanings and Symbolism

Artwork creates emotional responses from the viewer. Color psychology has linked certain colors to certain states of mind and emotions. If you want to create an abstraction that expresses a certain emotion, consider the following.

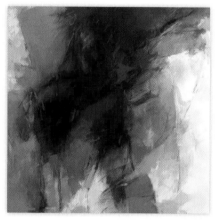

RED

Aggression, courage, danger, desire, motion, movement, passion, pain, power, revolution

ORANGE

Appetite, celebration, creativity, fitness, flavor, friendship, fun, generosity, happiness

YELLOW

Alertness, confidence, energy, intuition, joy, laughter, optimism, philosophy, playfulness

GREEN

Adventure, environment, freedom, generosity, life, nature, prosperity, renewal, quietude

BLUE

Balance, calm, contemplation, depression, harmony, peace, reflection, solitude, loyalty

VIOLET

Art, anxiety, enigma, femininity, mystery, royalty, sensuality, sadness, balance, dreams

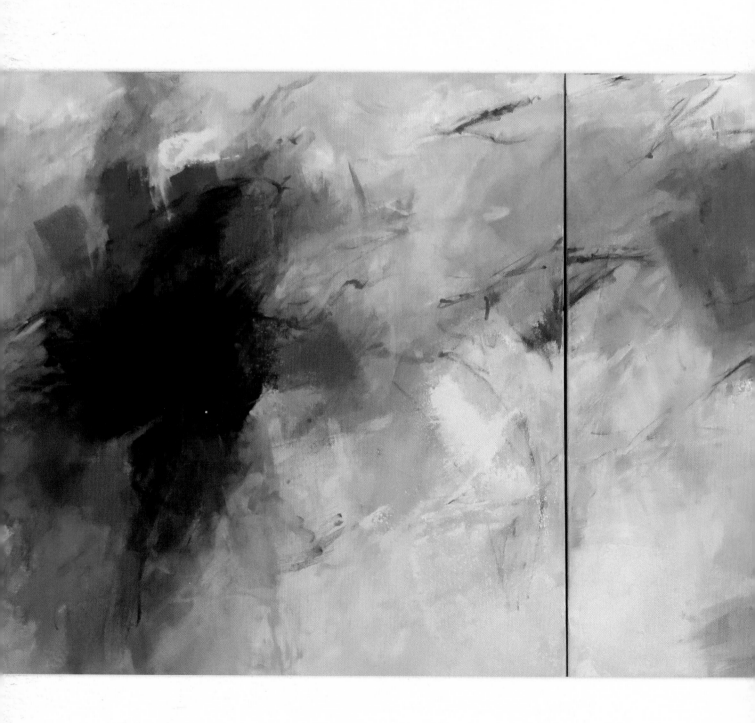

Abstractions
AND THE
Elements of Art

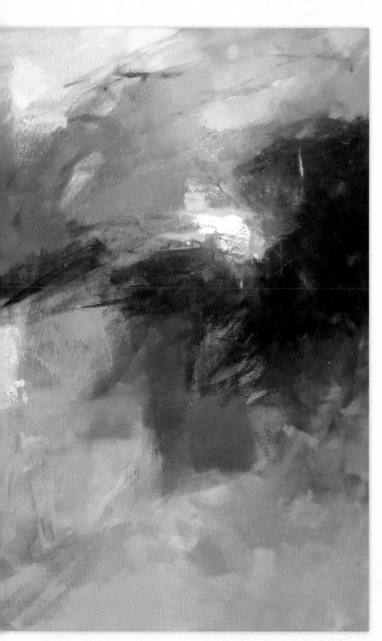

" Painting abstract expressionistic works are the most challenging as they entail all the elements of a first-class realistic piece of work, namely composition, values, which need to be addressed . . .

—ADRIENNE MOORE

The elements of art are the basic components of a composition whether it is realistic or abstract. You may use only a few within a painting or a drawing, but knowledge of them is very important. These elements also serve to help us assess our work as we progress. I have listed some basic elements of art and how they may be used within an abstract work.

Line

Line is the essential and foundational element of art. Line may indicate the contours of edges or the space between objects. Line may express movement and energy. The different qualities of line are also important. There is the depth and weight of the line. Lines may be short, jagged, sharp or smooth. Lines may be gentle and flowing. Line often expresses emotions and states of mind. Line expresses the individuality of the artist like handwriting.

You will want to incorporate different types and qualities of line within your work. This will add variety and interest. Instead of using the same width of line, try varying it from thin to thick or light to dark. Add emphasis with line in the focal area of a painting. Add line to create texture by using short, jagged lines in an area. Allow line to create movement as your eye follows it within the work. It may flow from one area of the surface to another.

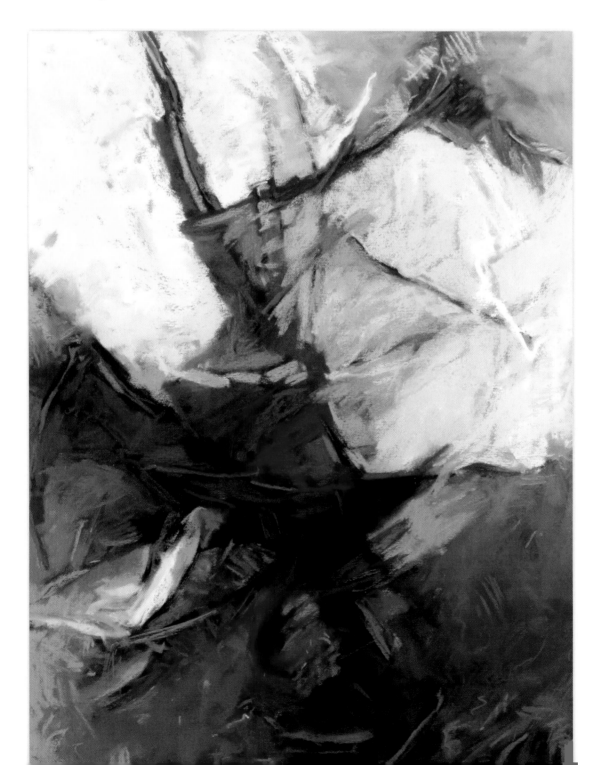

Shape

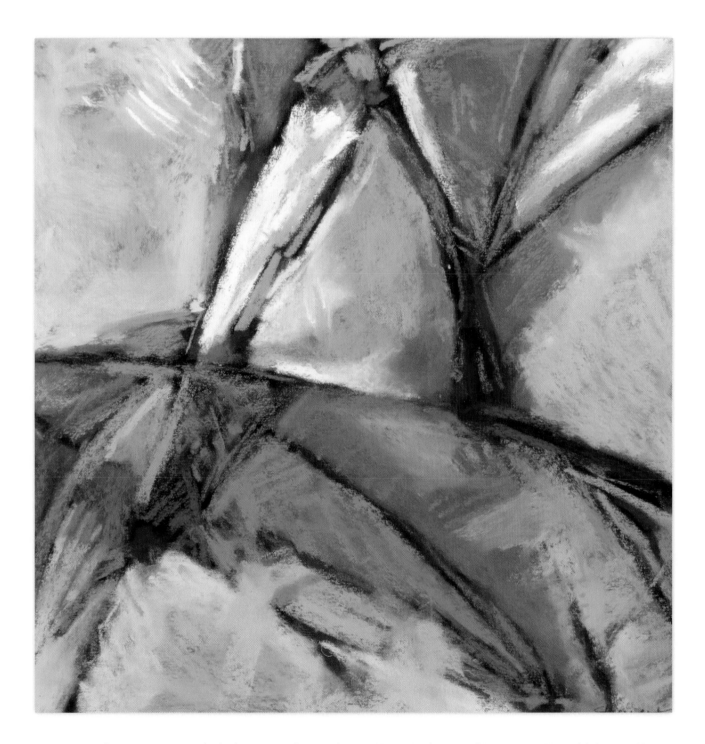

You can use shapes as a way to divide the picture plane and surface of the paper or canvas. The primary shapes within an artwork are organic or geometric. Abstract works also consist of shapes. In a grid abstract, the shapes may be composed of geometric squares or rectangles. An abstracted landscape may be developed from more realistic organic shapes. Another abstraction may be developed with shapes derived from a plant or flower.

Variety in shapes within a composition adds interest. You will want to vary the sizes and placement of shapes within your composition. Instead of two primary shapes, use three. Change the size of the shapes as this will also add interest. Placing the composition of shapes in an asymmetrical way is much more appealing than having all shapes the same size and arranged evenly within the composition.

For bonus content, go to: www.ArtistsNetwork.com/AbstractArtPainting.

Space

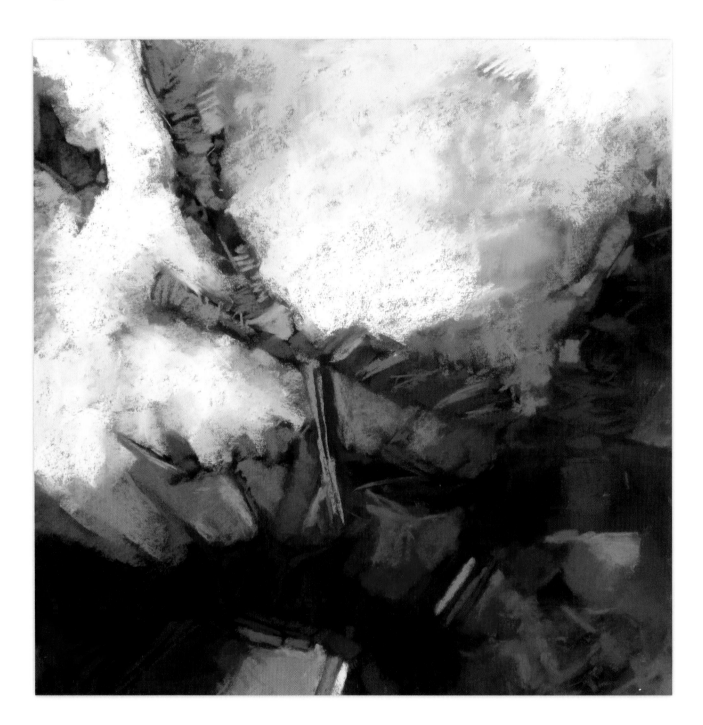

When you began to draw, you learned the difference between negative and positive space. The perception of space is as important in abstraction as it is in realism. Negative space is the space between or around the object. Positive space is the object itself and its place in the environment. Areas of quiet space in a painting may be contrasted with areas of activity.

Bring your attention to your environment and notice areas of negative space. Try drawing these areas and you may find future ideas for abstractions. It is not only an object that may give you ideas but the space surrounding the object. Space is also found within the shadows of an object. Space is important within the composition. You can add interest to your abstraction by creating areas of space or rest in contrast to areas of activity. Not every area of the paper or canvas has to be filled with details. Leave some areas open. This can help build atmosphere, energy and emphasis. If the entire work is active and busy, it may lack contrast and variety.

Texture

Texture is implied or real. You can develop texture in a variety of ways. Use mediums and gels to add actual texture to a canvas or paper. Develop implied texture with mark making or brushstrokes. Texture also creates interest within an abstract work. You may want to develop a highly textured surface, and you can do this with materials. You can build up the surface on a canvas with gels and grounds.

Experiment with the use of texture on paper or canvas. You do not have to texture the entire surface. You can bring texture to a certain area. Let the brushstrokes of your application add texture to the surface. To add surface texture to a pastel painting, use pastel ground on paper. Apply the ground with a brush, and when it dries, you will see traces of the application by brush. Incorporate these brushstrokes into the work. You can purposefully add direction to the texture by varying the direction of brush application.

Repetition

When you repeat textures, patterns, lines, shapes and other elements in a work, you are using repetition. Repetition adds rhythm and movement to the work. Repetition does not mean repeating all elements in the same way. You will want to vary size, shapes, colors and other aspects to add interest. If you are using a grid composition, you will be using a variety of squares or rectangles, but they will not be of equal sizes. Some may not have straight edges. Some may overlap others. Therefore, repetition does not mean everything is the same. Sameness does not add interest. Try using repetition within a pastel or acrylic painting. Repeat a line but vary its width, length, color or value. Repeat a shape but vary its size. You can create a series of works by using repetition. You may repeat a line or theme in each successive work.

Value

Value is the range of colors from dark to light. We can clearly see value in a gray scale. You see the range of shades between white and black. Colors also have value. Value adds dimension, focal points, depth and contrast to a work. Value may also express moods and energy. You may intentionally want a work that is very light or a work that is very dark in order to express an atmosphere or concept. Contrast in value adds drama and impact to a work. It is helpful to create a charcoal thumbnail sketch of an abstract composition to help you discover value in a potential work. This black-and-white thumbnail sketch is also helpful in choosing colors for a pastel or a painting. Thumbnail sketches help you visualize where the lights and darks will be placed within a composition.

Emphasis

Emphasis is the focal point within the painting. It grabs your attention. Your eye is naturally led to the focal point of a painting. It might be the lightest or the darkest area. This area stands out from the others in some way. You do not want all the areas of the painting to call for your attention equally. Ask yourself where you want the focus to be in your work. How can you achieve this? Is it through contrast between light and dark areas? Is it with complementary colors? Is it with texture?

Bring emphasis to your work in some way. Look at your work and ask yourself where you want the viewer's eye to be drawn to first. How can you achieve this? Will you heighten colors in this area? Will you add contrast in some way? Will you use complementary colors in this area for contrast? What area should stand out?

Color

It is important to understand color theory as it will help you choose colors. You do not want to use every color in your collection. You want to envision the basic colors in a composition and know how each color will react with another. Utilizing the color wheel will help you understand the basics of color theory. I use an analogous color wheel for most of my work. This helps me see complementary colors. It also helps me see other colors I can use to add emphasis in a certain area. I try to simplify my color choices in pastels and painting. I am always thinking of colors and their complements. I also strive to use grays and neutrals of the complements I have chosen for a painting. An early instructor once told me that we want people to walk away from our painting and remember "the yellow painting." We could not achieve that by trying to use every color.

The Other Elements

Other elements to consider when planning and evaluating your work are dominance, unity, harmony and balance. What aspect is most dominant in your work? What stands out the most? Does your painting have unity and work together as a whole? Is it harmonious in color, texture and technique? Is the work balanced? Have all aspects of the painting received equal effort and thought?

USE THE ELEMENTS TO EVALUATE YOUR WORK

Some artists want to know how to tell if an abstract work is "good." You can evaluate an abstract work by considering the elements of art.

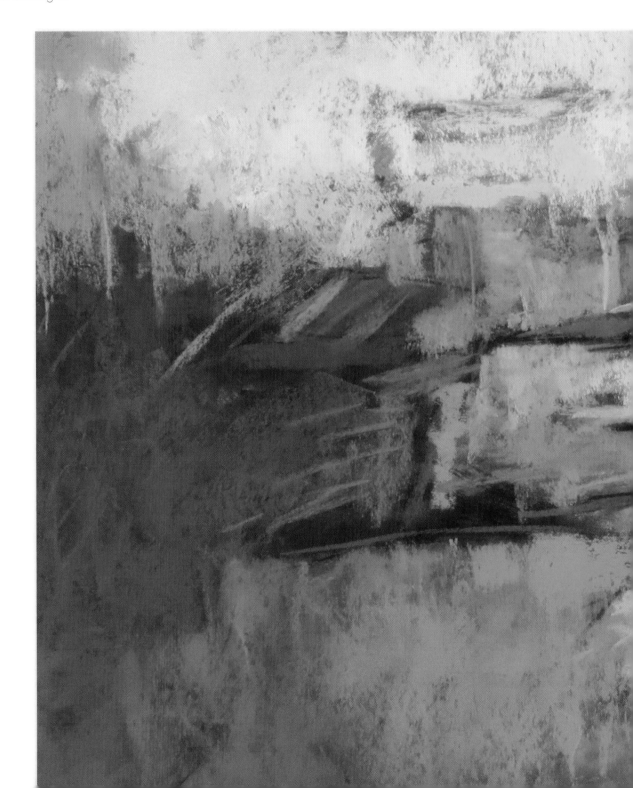

I often consider the following questions when I look at an artist's work:

Does the artist have skill using the materials? Has the artist mastered their materials?

Does the work have an impact on the viewer? Does it have a "wow" factor? Does it create a mood or atmosphere? Does it have an emotional impact on the viewer? Alternatively, does it fall flat or lack interest?

Is the work balanced and harmonious?

Does the work look thoughtful? Does it appear that the artist is working in a certain style and is thoughtful about where they are going with the work?

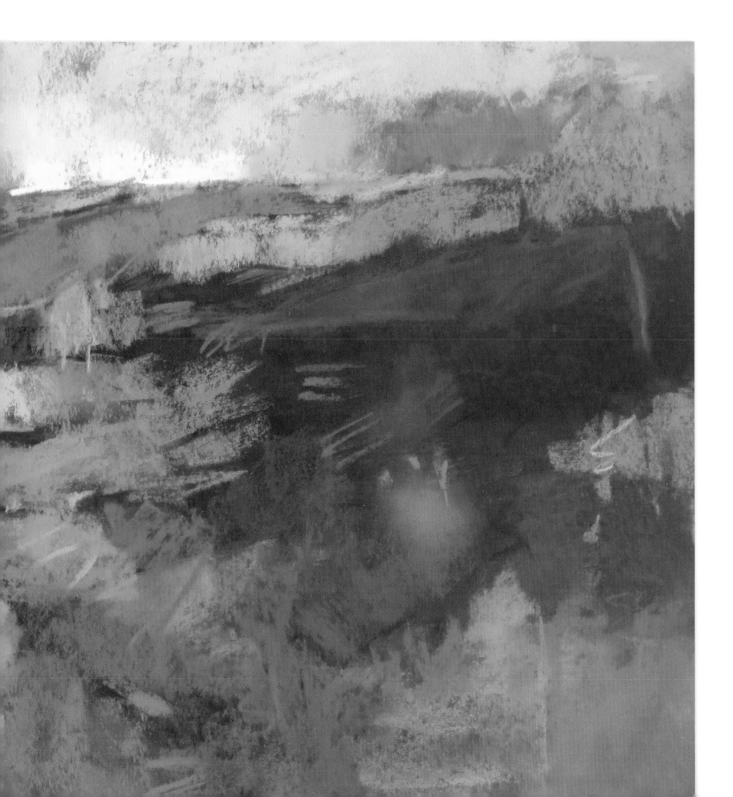

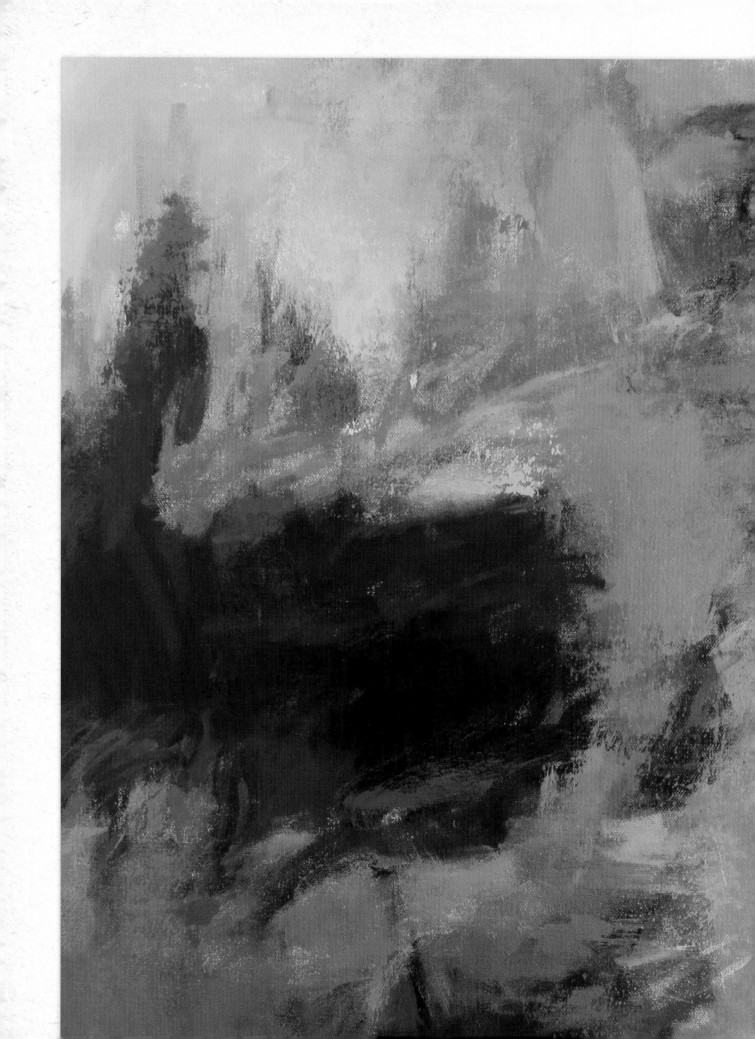

Compositional
Elements OF
Abstraction

" Abstraction allows man to see with his mind what he cannot physically see with his eyes. Abstract art enables the artist to perceive beyond the tangible, to extract the infinite out of the finite. It is the emancipation of the mind. It is an explosion into unknown areas.

—ARSHILE GORKY

Composition is the placement of elements within the work of art. Composition can make the difference between a good painting and a poor painting. Composition helps you determine the flow and division of space within the painting. This chapter contains ideas on developing abstract compositions and their descriptions.

The size and orientation of your surface will influence your compositions. A grid composition will take on a different look on a square or rectangular surface.

Elements of a Strong Composition

What makes a strong composition in comparison to a weak composition? The ability to create a good composition comes with practice and assessing your own work. Here are some key considerations in regards to composition.

BALANCE

A strong composition has balance. This does not mean that you can divide the work down the center. It means that the entire painting works together as a whole unit. It can be asymmetrical but is balanced at the same time. You may have a large shape on one side of the painting, but it is balanced by three smaller shapes on the other.

UNITY

All elements of the composition are unified. The painting works together as a unit. You have not used different styles in different sections of the painting. It has a unified color scheme. You will achieve better unity if you work on the entire painting instead of one section at a time.

FOCAL POINT

Even in abstraction there needs to be a center of interest or a focal point. Where is it that you want the viewer's eye to be drawn? The focal point is achieved through mark making or colors. This area stands out in contrast to the other areas.

VALUE AND CONTRAST

Have you used different values in your selection of colors? Are all the colors of the same value such as too light, too dark or too brilliant? A work is much more interesting if it has contrast and the values are varied within the work. A painting has more impact when it contains contrast.

VARIETY

Does the painting have variety? Variety is displayed through different mark making, brushstrokes, textures and patterns. You have varied your brushstrokes. In some areas you have used broad strokes of pastel, and in others you have more defined strokes of color. There is variety in the surface of the work. If everything is the same, the work lacks variety. Variety makes the work more exciting and interesting.

DIVISION OF SPACE

When you are creating a composition, you are dividing the space of the square or rectangle. Think about dividing the surface you are working on into different areas. These areas may be composed of organic or geometric shapes. Some paintings can become too complicated and have too many things going on. It is best to keep beginning abstractions simple. Think of dividing the square or rectangular shape of the surface into three or five different spaces. Within each of these spaces you can have different elements. Your work will benefit from keeping it simple.

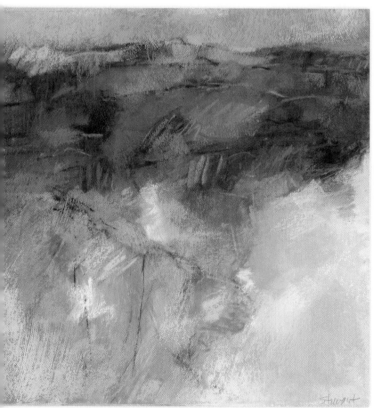

Circle or Closed

This type of composition refers to an object centered within the work. A shape is centered with space surrounding it on all sides. It does not extend out and beyond the edges of the surface but is contained within the painting. The painting may contain abstracted elements that are centered within a broader space that surrounds it. An example of this might be an abstracted flower composition. It is centered within the painting with space on all sides.

Choose a subject and simplify its elements to create an abstracted version. You might choose a shell, leaf, face, figure or animal. Place the subject within your composition with space surrounding it on all sides; you do not have to place the subject or shape directly in the center. Experiment with placement by moving it off center in your composition. Vary the texture and value of the surrounding space for interest.

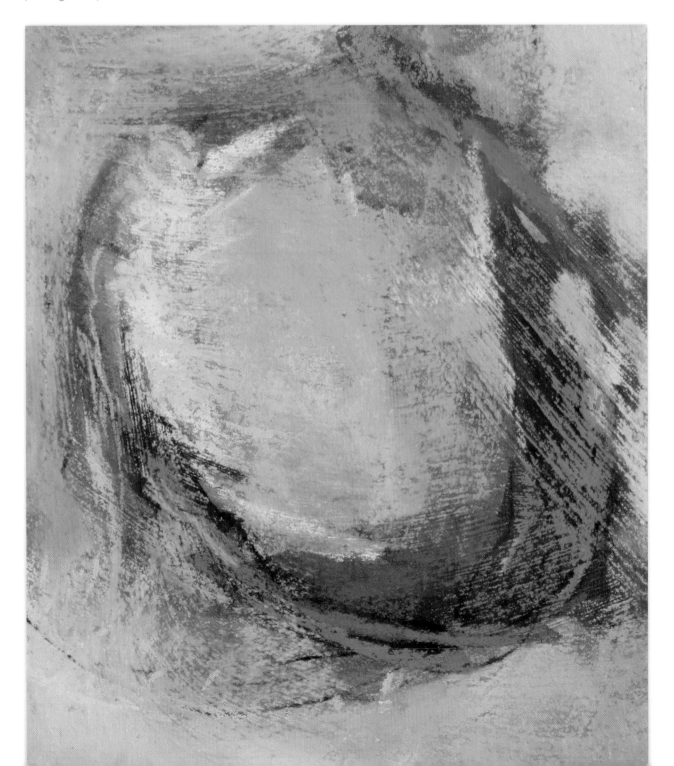

Grid

The grid composition is geometrical and usually contains squares or rectangles. The shapes may be various sizes. They may overlap or be only in one section of the painting, but the focus is on the grid. There are many variations of this composition. The grid may be obvious or more subtle within the abstract work. This composition is used often by abstract artists, and you will see many variations of its use.

Experiment with squares and rectangles in your painting. One way to play with composition is to cut various sizes and shapes of square and rectangular pieces of colored paper. Play with their placement on a piece of paper. Overlap some and leave space in certain areas. Look for compositions that you find interesting. Don't use too many squares or rectangles. You might begin by focusing on five square or rectangular shapes. Replicate these on paper or canvas for a mixed-media painting. Vary the value or texture within each shape. Use variety in elements to create interest.

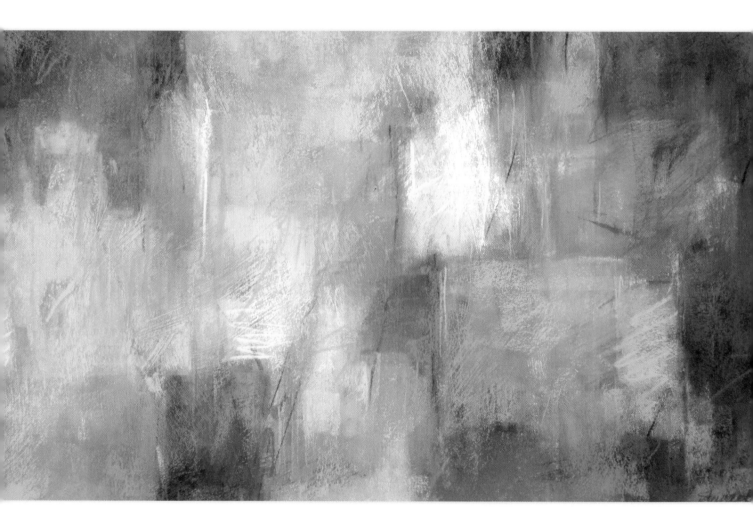

Triangle

Like the grid, triangles may overlap, be of different sizes and move off the page, but the basic shape is triangular. A portrait is often reflective of a triangular composition. Like the grid, this composition may be obvious or more subtle to the viewer of the work. The triangle may be geometric in form or might originate from a source in nature. A leaf might be an example of a triangular organic form.

Look for triangular shapes in photographs or sections of drawings. Where can you find triangular shapes in the environment? You might find them in the shadows between leaves. Create a triangular shape or shapes on your paper or canvas with masking tape. Use the same example mentioned in the grid composition section: Cut a variety of triangular shapes. Arrange them on paper. Overlap some, leave space in areas and find pleasing compositions. Vary the direction of shapes. Use these cut shapes as the basis for compositional thumbnail sketches.

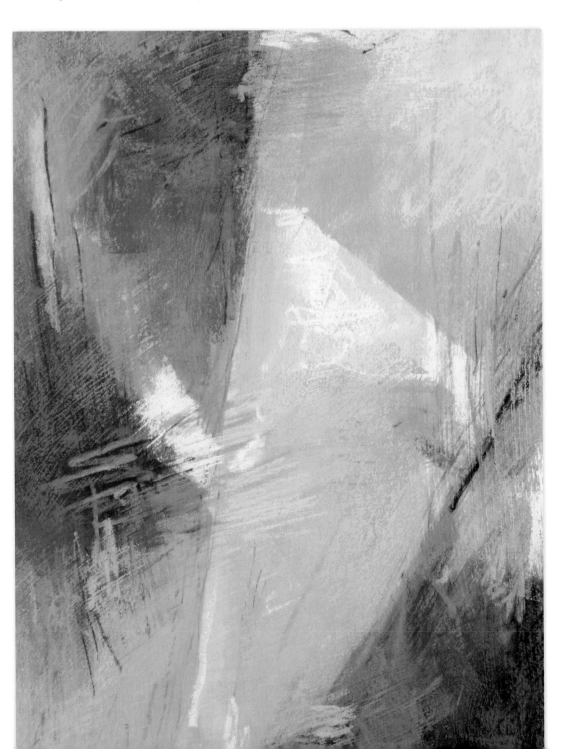

L Shape

The basic shape is the L and could be reminiscent of an interior or exterior. It can contain geometric or organic elements and is usually placed in an asymmetrical arrangement.

Create thumbnail sketches by using the L as your main compositional element. You can see in my example that I used the L but turned it on its side. You can vary the direction you turn the L shape. You can vary the thickness and the amount of space that surrounds it. You could even have more than one in your composition. Play with variations of placement and find a composition. Can you find an L shape in a photograph or section of a drawing? Can you find one in your home? You might also want to try looking through a viewfinder to locate this shape.

One of the important aspects to composition is varying the placement within the painting. Always look for variety. You can create many compositions by varying placement with each successive work.

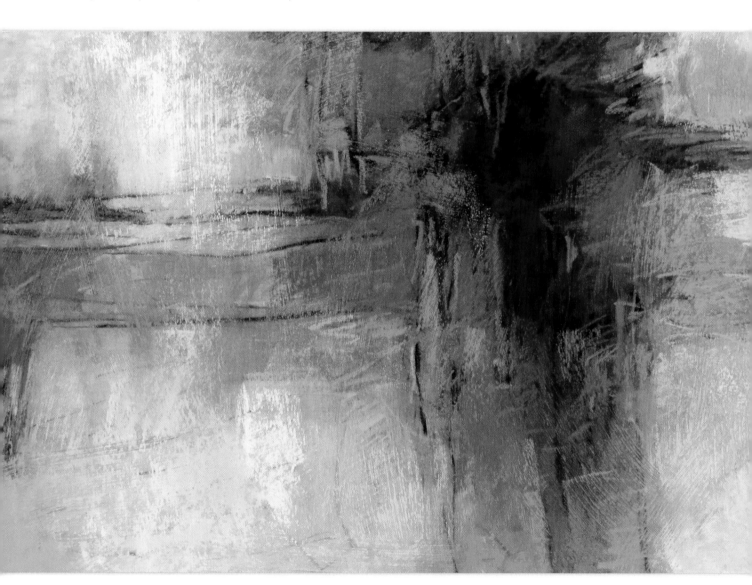

Diagonal

The diagonal line or division of space can have great impact. A diagonal composition can be powerful and energetic. It is best to avoid diagonal lines dividing the space equally. For example, you do not want to create a diagonal line from corner to corner on the canvas.

You can see in my example that I have a strong diagonal in my painting. It contains organic shapes but flows from one corner to the other. This creates a strong sense of movement. It appears to be moving up in the composition. For interest I cut the pastel paper and glued it to a backing board to create a diptych. If you want to create movement and a dynamic composition, try using a diagonal composition. Vary the direction of the angle and do not divide the canvas or paper in half equally. Avoid corner-to-corner compositions.

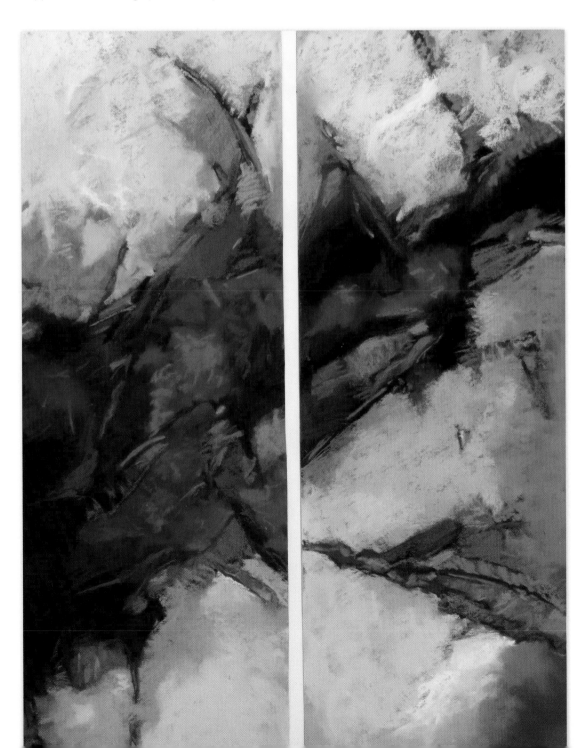

Symmetrical

Symmetrical means all elements are arranged equally in the space of the painting. In this composition, all elements are of equal weight. We can divide the painting in half and each half is equal. Many optical art paintings are symmetrical. The painting is balanced and harmonious.

Symmetry does not mean that the painting is the same on both sides. I consider my pastel painting *Bouquet* to be a symmetrical painting. I find that it has equal balance on both sides of the painting. Both sides are not identical but they have equal weight. It is basically centered within the composition with equal space on both sides.

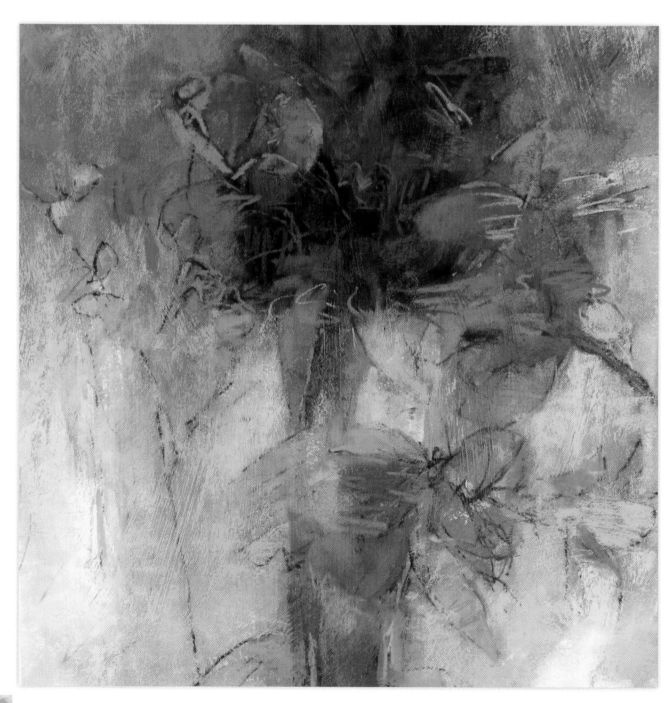

Asymmetrical

In this composition, elements are not of equal weight. We may have two small elements on one side of the canvas and one larger element on the other side. Though the elements are not equal, there is balance and harmony within the composition.

Try varying the main element of your composition. In the example of my self-portrait I have placed my face to the right side of the composition. Space exists on the left side of the portrait. This creates more interest than placing the face directly in the center of the painting. The space adds more mystery. The face may even be moving away from the center of the painting. I tend to prefer an asymmetrical composition because I find it more interesting. Place the main element of your composition off center, in the upper third or lower third of your composition. You will still need to bring balance to your composition. I have brought balance to this portrait through the use of lines and shapes on the left, which balances the large shape of the head.

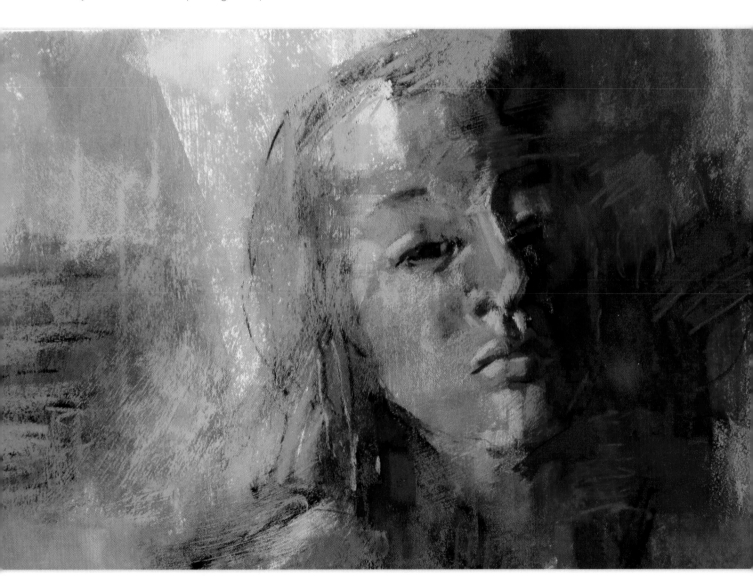

Cruciform

The cruciform composition may be one of the oldest. We see elements of the cruciform from the earliest times of human history. The cruciform is more varied than dividing the space into four equal areas. Use a variety of different placements of vertical and horizontal crossing lines to create variations on the cruciform composition. You can also have different elements within each space of the cruciform.

Use the cruciform shape to create a variety of compositions. Vary the quality of the line. Sometimes you may use straight lines and at others more curved lines. Vary the space within each section of the cruciform. At times you can have more space at the bottom or at the top. You can vary the axis of the cruciform and place it off center. Vary the width of the lines in the cruciform. Vary the textures, values and patterns within the cruciform.

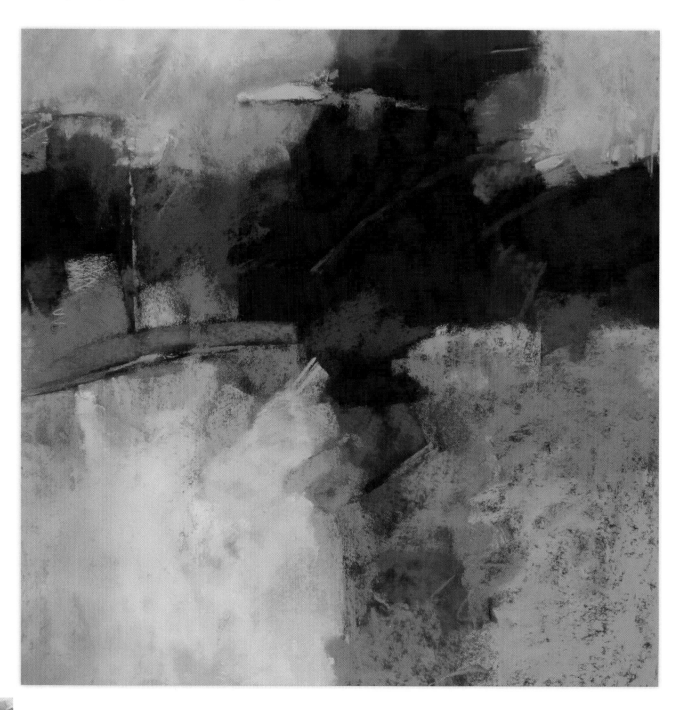

S or Z Curve

This composition may be most evident within a landscape painting where you see the Z or S in the bend of a road or river. You can also use this composition within an abstract painting. Avoid dividing the surface equally with a Z or S curve, and try variations of placement and movement within the picture plane.

Look through photographs and see if you can find an S or Z curve. You may find this in photographs of landscapes. Simplify all shapes and re-create them on your surface. Some-times you can leave more space at the top and other times more at the bottom. My example is a very simplified version of a stream or river. I did use a photograph for the basic flow of the S but I varied it once I began to work.

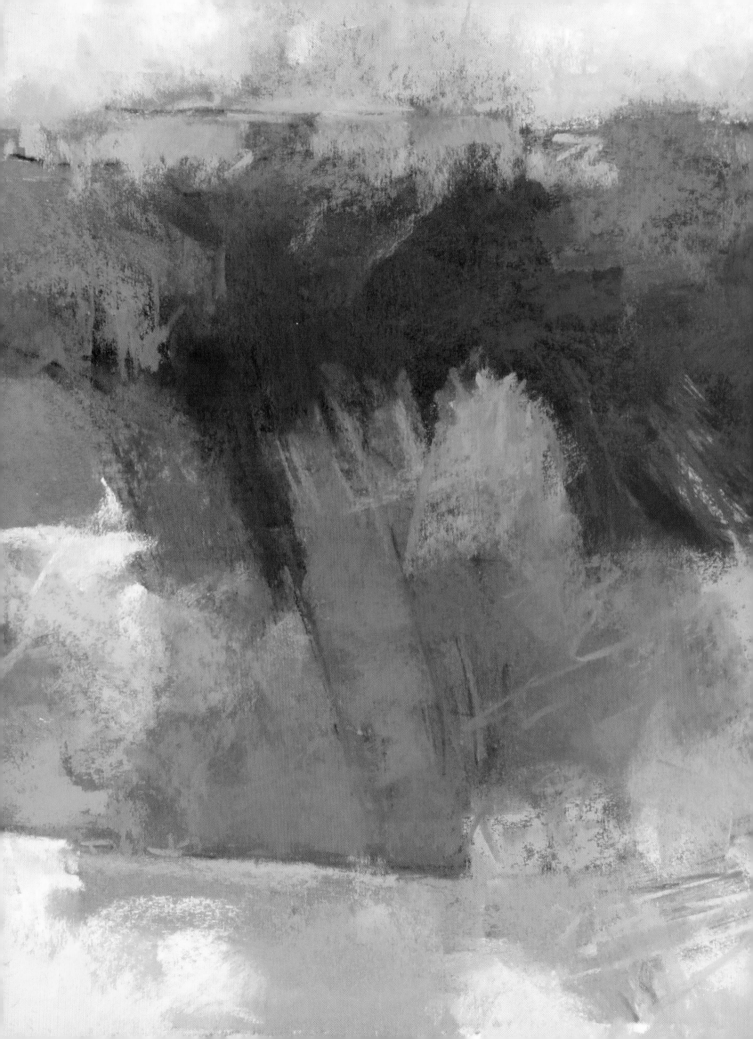

Thumbnail Sketches AND Source Drawings

6

" Strong abstract design is created with rhythms and harmonies in shapes, lines, edges and colors and is analogous to the rhythms in music and the harmonies between individual notes. This aspect of the painting is completely independent of the subject matter.

—BARRY JOHN RAYBOULD

Many landscape artists use notans to create compositions. The notan is a small black-and-white drawing that contains the basic composition and shapes of the landscape. They help the landscape artist arrange the surface and simplify the composition. An abstract artist may use the same technique to help create compositions. I refer to these small sketches as "source drawings."

Creating small source drawings and thumbnail sketches can help you develop abstract compositions. These small works help you work out composition and color choices before investing in a large sheet of paper. In abstraction, we often do not have that reference photograph to work from, so we need something to help us along the way. This source drawing can be our guide.

There are different ways you can develop source drawings. I have used three primary methods to create small source drawings. These methods include using photographs, line drawings and sections of previously completed drawings or paintings.

Using a Photo for Inspiration

You can use photos for inspiration in creating abstractions. I used this technique when I first began working with abstracts, and it proved very helpful in finding abstract compositions. Take a simple black-and-white photograph to find sections for abstractions. You can use a viewfinder to locate possibilities or you can cut the photograph apart. I recommend using a photograph in gray scale. This helps you be creative with color schemes and focus only on shapes and lines. Use small sections and draw thumbnail sketches for compositions.

What You Need

- newsprint
- photograph
- pastels
- viewfinder or scissors

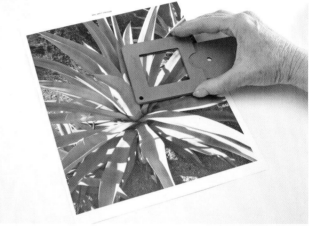

1 Choose a photo to work from that does not have a lot of details or texture. It is best to work from a gray-scale photo in order to be more interpretive with color.

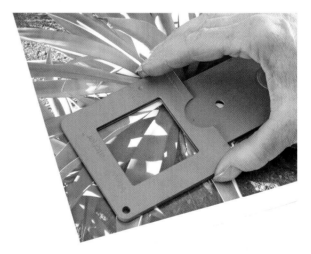

2 Use a viewfinder to locate a section of the photo for your abstract composition. Look for sections that have clear shapes. Try finding an area with three or five main shapes. Look for parts of the photograph that also have contrast.

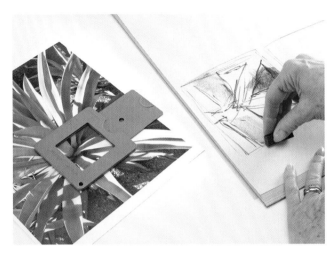

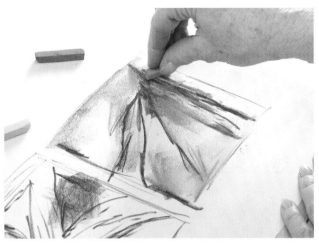

3 Sketch a square or rectangle on your paper. Draw the main shapes you see in the viewfinder. Pay attention to the lights and darks of your composition. Divide the composition into three or five main areas. Create different thumbnail sketches based on each of these areas.

4 You can add one or two colors to this simple thumbnail sketch. The color may reflect the underpainting you can use in your abstract painting. Do not try to replicate the colors of the original photograph. Be creative with your color choices. Try choosing complementary colors.

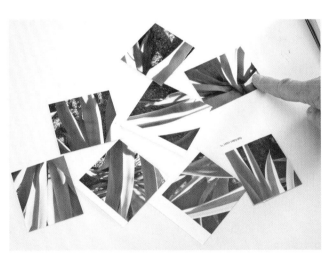

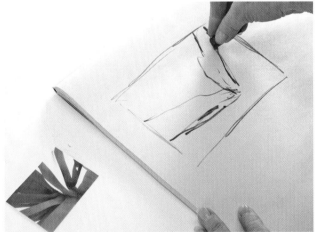

5 Another way to get ideas is to cut up a photograph and look for simplified shapes. Take a copy of your photo and cut it into pieces. The shape doesn't matter. Pick one of them and sketch it on your paper, making sure to look for simplified shapes.

Using a Contour Drawing for Inspiration

Draw something from observation and use this as a basis for developing abstractions. You can draw whatever you like. I usually draw plants, flowers or grasses. I only use this to gather lines and shapes as you can see in the photographs. The subject of the drawing is not the most important thing. I recommend drawing from life, but if you cannot, choose an appropriate photograph to use as subject matter. I use blind contour drawing. I focus on the subject (here, a bouquet). I follow the edges, shapes and lines of the various flowers, stems and leaves. I am not concerned about drawing accurately, but I am concerned about observation. You can use a contour drawing in the same way you would use a photograph. Take the viewfinder and locate possible sections for compositions. I choose sections that simply have shapes and lines connected to the edges. I don't use lines that are floating or disconnected to the edges. I also like to choose areas that have some open space.

What You Need

- charcoal
- newsprint
- pastels
- viewfinder

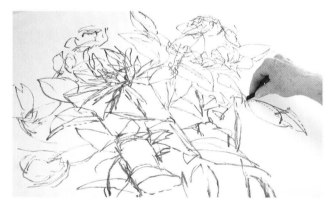

1 Use a round compressed charcoal to sketch a blind contour drawing. When doing this type of drawing, don't be concerned with reproducing an exact image of what you are drawing.

2 Use the viewfinder to look for different compositions that emphasize basic shapes and space that attract your eye.

3 Sketch the image in your viewfinder but consider various ways to divide the shapes; you don't have to perfectly re-create what's in your viewfinder. You might end up using darker or lighter colors than what you see in the original sketch. Emphasize what you like most about the portion seen in your viewfinder.

Spontaneous Line Drawings

You may also create ideas by using some spontaneous line drawings. After you have completed these, you can take sections and use them for abstract compositions.

Use charcoal or pastel and large paper. Put on some music that you like and draw to the music.

While creating these drawings to music, keep some of the following ideas in mind.

- Vary your line from thick to thin, jagged, curved, broken, etc.
- Draw with both the point and the side of the charcoal and the pastel.
- Vary the position of the marks on the paper.
- Let your marks respond to the music you are listening to.

This is a very good exercise to help you loosen up, especially if you are in a period of feeling stuck.

Use your viewfinder to locate areas of these spontaneous line drawings. Do you see areas of interest? Do you see interesting areas that are possible compositions for abstractions?

This is similar to the warm-up exercise at the beginning of the book on drawing to music. In this instance, you are using sections of these drawings for abstract compositions.

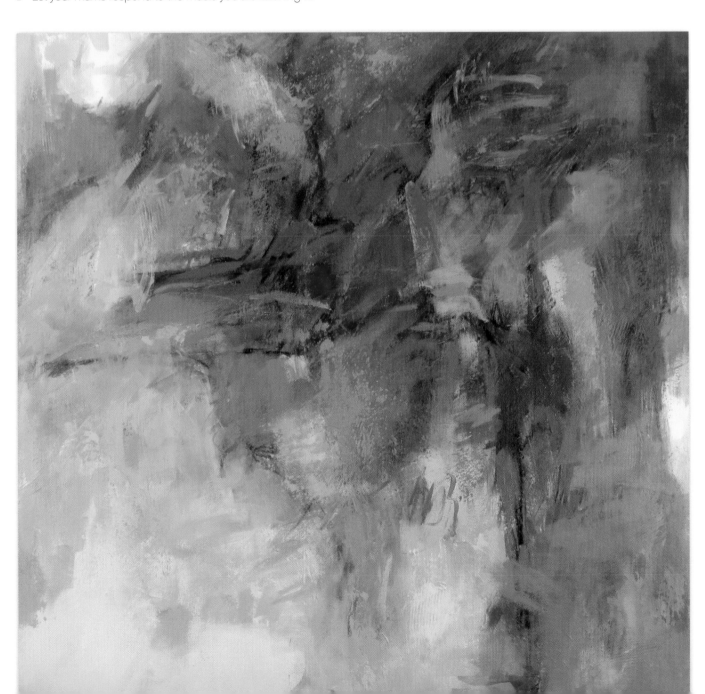

Using Existing Artwork as Inspiration

Take a pastel or painting you have completed and use it as inspiration for another work. You probably have many images of your work on your computer. Take one of these images and crop various sections. Take a section and use it for another painting. You can use the same colors or different colors if you wish. My example shows a pastel created from a bouquet of flowers. I took this photo and cropped a small section. I printed this section in gray scale to better see the difference in values. I used this small section for my acrylic painting. Use existing artworks to create follow-up works. This will also help you in developing a series of works with the same theme.

Creating
Underpaintings

" I never wanted color to be color. I never wanted texture to be texture, or images to become shapes. I wanted them all to fuse together into a living spirit.

—CLYFFORD STILL

The use of an underpainting can be the key to developing a more dynamic pastel or acrylic painting. You can use the same materials for both mediums. An underpainting helps you work out many elements of your work before you add a final layer of pastel or acrylic paint. Spending more time in this stage will result in a more successful painting.

Underpainting helps you:

- Bring more structure and depth to your work
- Develop your composition
- Clarify your color scheme
- Bring movement and energy to a work

Types of Underpainting

I have experimented with various types of underpainting for both pastel and acrylic painting. This experimentation has led me to techniques I use today and has helped me in developing my work. In this chapter, I will share the different materials you can use for underpainting. I encourage you to try them all and see what works best for you.

UNDERPAINTING FOR PASTEL PAINTINGS

Charcoal

Use charcoal to create a value underpainting. Draw directly on the sanded paper and wash with a wide brush dipped in rubbing alcohol. A little charcoal goes a long way. Using charcoal as an underpainting helps you develop more value and contrast in your work.

Pastels

Use hard pastel or soft pastel with rubbing alcohol for an effective colored underpainting. Rubbing alcohol helps liquefy the pastel so you can more easily apply additional layers.

Watercolors

Use watercolors on sanded and textured papers to create a fluid look to your underpainting. The fluidity of watercolors and pools of color can create a fun surface for your pastel paintings. You can also use watercolors on a variety of heavy papers and apply a pastel ground over the dried painting.

Oil paints

You can apply oil paints to the surface of sanded paper very effectively. Oil paints give you a similar appearance to watercolors, though they may be more intense in appearance and less fluid. You can use either water-based oil paints or regular oil paints. Allow more time for this underpainting to dry before using the paper. You may also need to flatten your paper before applying pastel. Anytime you get paper wet, it has a tendency to buckle. Some papers buckle more than others. You can flatten paper by letting the paper dry under some heavy books or a board.

Acrylics

You can use fluid acrylics on sanded paper, watercolor paper or printmaking paper. Fluid acrylics dry fast and allow you to work immediately. The intensity of color varies with how much water you use to dilute the paint. I prefer using fluid acrylics for my underpaintings in pastel.

You can also use regular acrylics on paper and apply ground over the painting for pastel works. I do not recommend using regular heavy-body acrylics on sanded paper as it will clog the surface of the textured paper. You can thin regular acrylics with water or gel medium as an alternative to fluid acrylics.

ADDING VALUE TO THE UNDERPAINTING

You can add a value drawing to the prepared surface of the pastel painting. Apply your underpainting first in watercolor, acrylic, pastel or oil paint. After this initial underpainting is dry, you can add a charcoal value drawing on top of the underpainting. Follow your initial thumbnail sketch or color study, and apply charcoal and/or hard pastel lines. This is only meant to be a value drawing to help you bring out the value of your finished work. You may decide to let certain areas show through your finished work. You can then wash with rubbing alcohol, which will set the charcoal to the surface. This will help you choose the appropriate values for your pastel painting.

UNDERPAINTING FOR ACRYLIC PAINTINGS

Fluid acrylics

Use fluid acrylics for the initial wash of color to assist you in clarifying your composition. You have identified your color scheme, and perhaps it is primarily red and green. Apply a first wash of fluid red acrylic based on your initial composition sketch. I have found that using acrylic gel helps in applying this first layer of acrylic. Using a thin wash of color also helps you in developing multiple layers of acrylic and creating a more interesting texture in the final work.

Colored gesso

Using gesso as an underpainting is very effective in the beginning stages of developing your painting. Use your initial sketch and color scheme to determine what color of gesso to use. You can also mix black and white gesso to get different values of gray. Doing this really helps bring out values and structure in a painting.

UNDERPAINTING COLORS

Same color scheme

You can use the same color scheme that you have chosen for your painting. If you want to create a painting or pastel in a red and green color scheme, use the same colors for your underpainting. You apply basic underpainting based on your small thumbnail sketch. No details are added to the underpainting. The underpainting serves as a method to help you divide the space, and create value and movement. Your paint or pastel is applied over the top of the underpainting in similar colors.

Complementary colored underpainting

You can use the complement of the color scheme for your underpainting. If you create an abstracted landscape in blues and greens, your underpainting will be warm colors of reds, oranges or Burnt Sienna. This gives the pastel or acrylic painting added dimension when you allow some of the underpainting to show through the work. Your colored underpainting adds an important dimension to the finished work.

Charcoal or Pastel and Alcohol on Sanded Paper

This series of photos shows the use of charcoal and hard pastel for underpainting. Charcoal and alcohol will create a value drawing, which will help you in choosing the correct value of pastel for your painting. You may apply the charcoal to a white or toned sanded surface.

Hard pastel and alcohol can also be used as a colored underpainting. The underpainting helps you work out many compositional elements, values and color schemes before actually applying the final layer of soft pastel. It helps you loosen up your style and work more expressively.

What You Need

- compressed charcoal
- hard pastels
- masking tape
- reference photo or sketch
- rubbing alcohol
- sanded paper, gray and white (Wallis)
- wide flat paintbrush

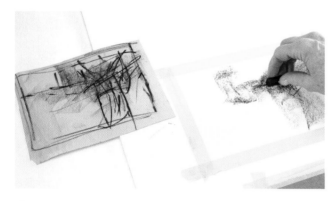

1 Tape down the white sanded paper on all sides to keep it flat and to give it a border; otherwise the paper will bend. Place your reference photo nearby, and using compressed charcoal lay some lines down onto your paper. Apply the charcoal lightly, not pressing too hard.

2 Dip a wide paintbrush into rubbing alcohol.

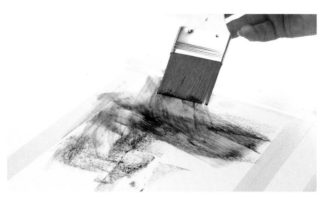

3 Apply the rubbing alcohol to your charcoal. You are creating a value wash with the charcoal. Do not apply detail in this stage. Work quickly and expressively.

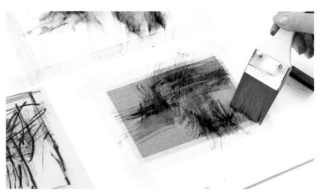

4 Use this same process on gray sanded paper or another toned textured surface. You can see that you now have a basic composition in values to use for your abstract.

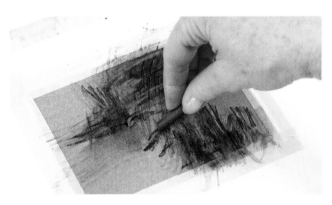
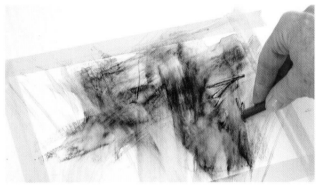

5 When both sketches are dry, go back and pick up some of the lines that were made by the brush. Refine these lines into the abstract by emphasizing them with darker and lighter tones.

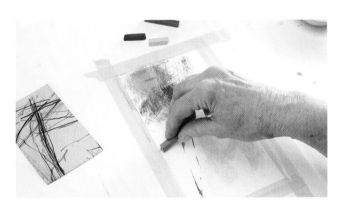
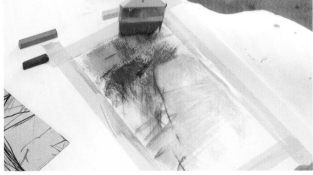

This process works exactly the same with hard pastels instead of charcoal. Use alcohol to dilute and wash the hard pastels onto the sanded surface. Work quickly and do not add any detail to your painting. You are only using the pastel as an underpainting.

Colored Gesso on Canvas

The photographs on this page illustrate using colored gesso on a canvas paper. The same technique can be used on stretched canvas or panel. Gesso comes in a variety of colors including black and gold. I often use colored gesso to begin an acrylic painting on canvas because it helps me block in the major shapes of my composition. It also helps me determine the open space of the composition and the underlying values for my color scheme. You can mix colored gesso to create a different color. You can use more than one color on a canvas. You can draw on the canvas with colored gesso and a brush. I find the gesso really helps get the painting started.

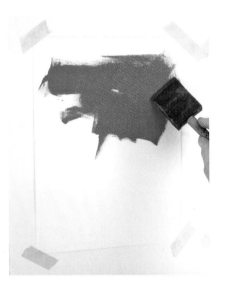

1 Use your thumbnail sketch as your guide in applying colored gesso to the painting surface. Apply the gesso as an underpainting. You may apply it with a sponge brush or flat brush.

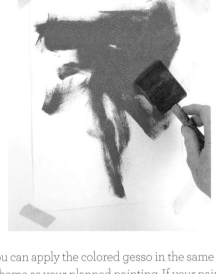

2 You can apply the colored gesso in the same color scheme as your planned painting. If your painting is primarily red you may use red gesso. This will help you work out the large shapes in your composition. You may also use the complementary color of your dominant color scheme.

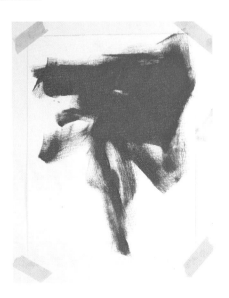

3 Colored gesso as an underpainting will also help you work out the values of your painting. Leave open areas with no gesso for the light areas of your painting. You can also mix gesso to obtain a darker color. You could mix a little black into the red gesso to achieve a darker value of red.

Fluid Acrylic on Canvas or Sanded Paper

CANVAS

Fluid acrylics can be used in the same manner as the colored gesso. Fluid acrylics provide more of a transparent wash. Colored gesso is opaque. You may want the wash of fluid acrylic to show through your finished painting. Each will provide a different effect, so which one you use depends on what you want to achieve.

What You Need

- acrylic matte medium
- backing board
- canvas
- flat paintbrush
- fluid acrylics
- hair dryer
- masking tape
- palette
- reference sketch
- soft watercolor brush
- white sanded paper (such as Wallis)

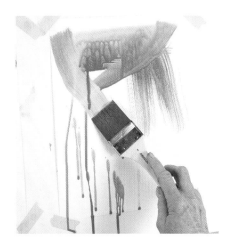
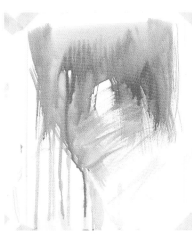

1 Put a little fluid acrylic on a Styrofoam plate and mix with matte medium. (I have found this aids with adhesion to the canvas.) Thin this a bit with water and apply it to the canvas in broad washes using your thumbnail sketch as your guide to create an underpainting in the same manner as the colored gesso.

2 Textures and brushstrokes in this stage may be incorporated into your final painting. I really like finding those interesting lines and textures that will contribute to the excitement of the painting.

SANDED PAPER

Use fluid acrylic on paper such as Rives BFK and sanded surfaces. You can create intense washes of color with fluid acrylics. Use a soft brush and plenty of water. Add more water to lighten and use full strength for intense saturation of color.

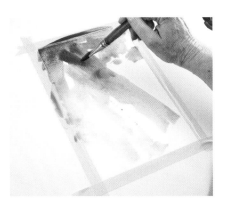
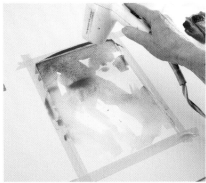

1 Secure the paper to a backing board with masking tape. Dilute fluid acrylic with a little water before applying it loosely to your paper, using. your thumbnail sketch as a guide. Wash the acrylic with water where the composition will be lightest.

2 Dry the paper with a hair dryer to continue on to the next stage of your pastel painting. Taped edges of the paper will help keep the paper flat and will give you a nice border for framing your finished pastel painting.

Watercolor or Oil Color on Sanded Paper

Watercolors can be used on a sanded and textured surface like Wallis or UART paper to create a colored underpainting, using one color or more. Let one layer dry and add additional watercolors. Splash and drip watercolors to create interesting colors. Use many of the same techniques you would with a watercolor painting for this beginning stage of your pastel painting. Be experimental because you will be layering pastels on top of this initial painting.

You can also use oil paints on a sanded surface. In this illustration I am using water-based oil paints on a sheet of white Wallis sanded paper for pastel. Dilute water-based oil paints with water.

What You Need

- masking tape
- paintbrush
- palette
- paper towel
- reference sketch
- sanded paper, gray and white (Wallis or UART)
- watercolor
- water-soluble oil colors

WATERCOLOR

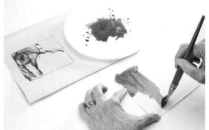

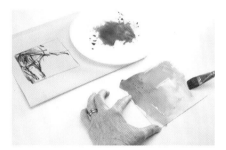

1 Dilute the watercolor on a surface other than your paper. Here I am using a foam plate for a palette.

2 Apply the watercolor onto your paper using a wide watercolor brush. Set your thumbnail reference sketch by your painting.

3 Apply the darker watercolor in the same area as the darkest area of your sketch. Your sketch can help you see the light and dark areas of your composition.

OIL COLOR

1 Apply the diluted oil paints using your sketch as a guide.

2 Add additional color to your underpainting.

3 Blot areas with a paper towel to lighten. Use the accidents and textures created by the water and paper towel in your finished pastel painting.

Adding Value to the Underpainting

Use a combination of charcoal and paints to prepare an underpainting for your pastel painting. I have found that combining charcoal at this stage helps add depth and value to an underpainting. I use my sketch as a guide. Many of the charcoal lines will not be evident in the finished pastel painting. You can use this process on sanded paper or paper that you will apply pastel ground to.

What You Need

- acrylic paints
- charcoal and/or hard pastels
- hair dryer
- masking tape
- paintbrush
- palette
- reference sketch
- sanded paper (Wallis)

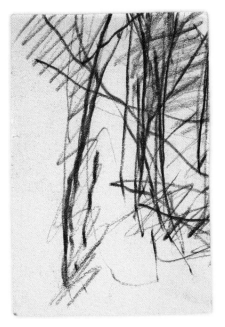

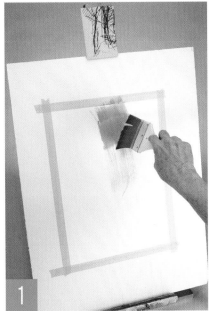

1 As with all underpainting techniques, begin with a reference sketch you are happy with. Using a diluted acrylic paint, try to replicate the image with strokes of paint.

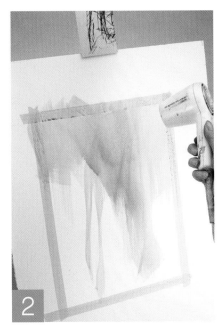

2 Dry the underpainting with a hair dryer to work quickly and to prevent the paper from buckling.

3 Draw into the underpainting with charcoal and/or hard pastels. Draw loosely and do not focus on detail. Use some of your brushstrokes to guide your mark making.

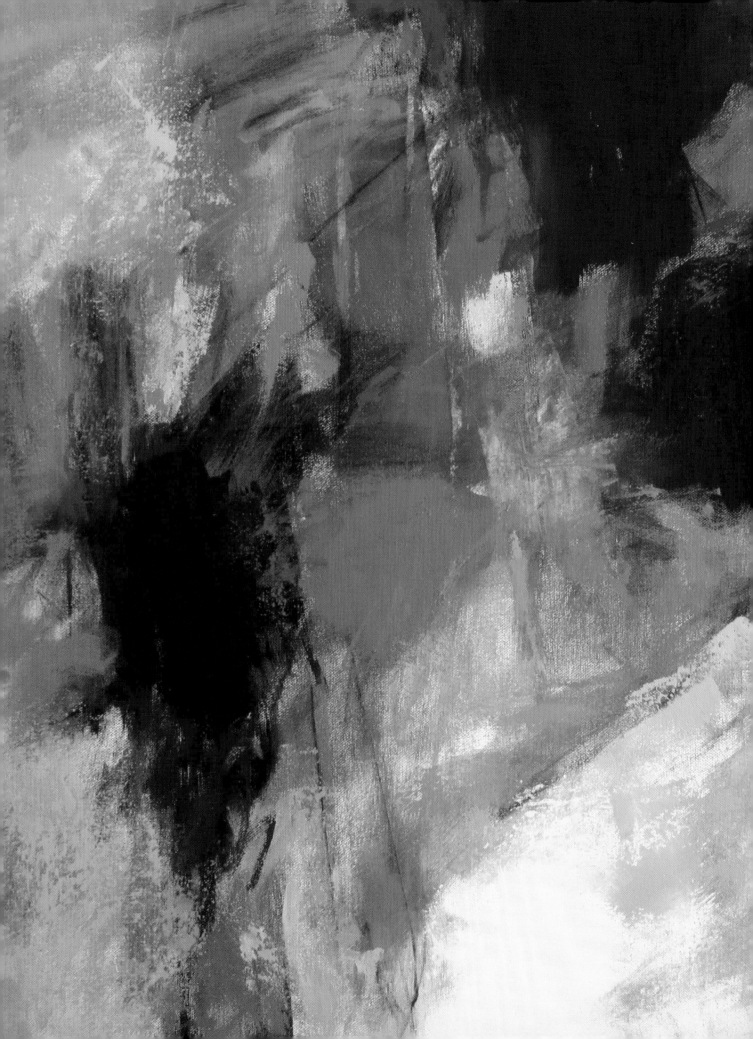

Working WITH
Acrylic Grounds
AND Mediums

"If you work with abstract painting for a period of time, you may come to think of it as a melody, a song, a piece of beautiful music.

—JUDI BETTS

Texture is another element that will create a more dynamic painting or pastel. Bringing texture into your work adds to the surface interest of the finished painting. Many different types of grounds and pastes are available to build up the surface of paper or canvas. You can use texture in small areas for emphasis, or you can texture the entire surface. Many materials are interchangeable. You can use gels and pastels on both canvas and paper. You can add color to grounds and pastes to create a tinted texture.

Adding Pastel Ground and Molding Paste to the Surface

You can use acrylic pastel ground and molding paste to build up the surface of your painting to create additional texture and depth. Pastel ground can be used on both paper and canvas. Molding paste is generally used only on surfaces for painting, such as stretched canvas or painting panels. Texture can be enhanced with knives, combs and other tools. You may find tools around your house that you can press into the molding paste to create additional texture.

What You Need

- acrylic ground
- flat paintbrush
- molding paste
- palette knife
- surface of choice—paper or canvas
- texture tools—combs, sponges, screens, etc.

ACRYLIC PASTEL GROUND

Pastel ground has really changed the way I approach pastel painting and has become a regular part of my work. I love its flexibility and have used it in many different ways: tinted it with fluid acrylics, used just a little to build up an area on sanded paper, used it on paper that has an underpainting and drawing.

Pastel ground is fairly transparent so it can also be applied over an acrylic underpainting on canvas. After the ground dries you can draw with charcoal or pastel. I don't recommend using soft pastel on canvas.

MOLDING PASTE

A wide variety of molding pastes are available to create interesting surfaces on canvas. Pastes can be added to a primed canvas. Texture can be added to the pastes with different tools like combs, color shapers and painting knives. Color can also be added to molding pastes to create a colored paste to apply on canvas. Pastes come with a variety of textures, including those with fine or course pumice to add a gritty look to your canvas.

1 Apply acrylic ground for pastel to a surface using a palette knife or a brush.

2 Spread the ground smoothly and evenly, or you can vary the texture in places.

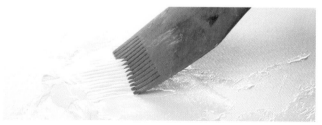

1 Use a palette knife to apply molding paste to the canvas. You can apply it to the entire surface or certain areas of your canvas. It will take at least 24 hours to dry.

2 Add additional texture to the paste by using various tools to create texture. Here I am using a painting tool. You could use a comb for the same effect.

Mixing Fluid Acrylic with Pastel Ground

You can mix fluid acrylic paints into pastel ground to create a toned ground for pastels. I don't recommend using regular acrylic paints for this as it would affect the quality of the ground. Fluid acrylics have an intense tinting strength. You do not need much to add color to the ground. Think about the color scheme of your painting when you choose what color to tint the ground. Try using a complementary color in your tinted pastel ground. I have often used red and orange to complement blues or greens in my paintings. These warm colors really add an extra dimension.

What You Need

- fluid acrylic paint
- hair dryer
- making tape
- paintbrush
- palette
- palette knife
- pastel ground
- paper (BFK)

1 Use a palette knife to add some pastel ground to your mixing plate or palette. Add a drop or two of fluid acrylic to the ground. Add more if you want a more intense tint.

2 Use a palette knife to blend the two together.

3 Tape your paper down to keep it flat. Wet a wide brush in water and apply the colored ground to your paper. I use a slightly wet brush because it helps dilute the pastel ground. You can also add a little water to the ground mixture and mix with your knife. Let the surface dry thoroughly before using. Use a hair dryer to dry more quickly.

Applying Pastel Ground Over Acrylic Paint

Using a paper such as Rives BFK or Stonehenge, begin by taping down all edges of the paper to keep it flat like you would for a water-color painting, then paint an underpainting with fluid acrylic. This gives you an initial wash of color and helps build the underlying structure of your work. You can draw on the underpainting with charcoal and hard pastel before applying the ground. After the underpainting is dry, go over it with pastel ground, applied with a slightly damp wide brush. Experiment with how much you want to dilute the ground. After applying the pastel ground, dry with a hair dryer to help keep the paper flat.

What You Need

- acrylic pastel ground
- fluid acrylic
- hair dryer
- masking tape
- paintbrush
- paper (BFK)
- paper towel

1 After taping down your paper, apply fluid acrylic paint to the surface. Leave some white areas.

2 Once applied, use a paper towel to pat some of the excess paint away.

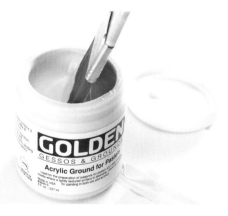

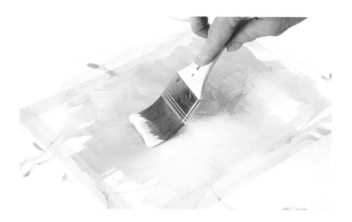

3 When the paint is dry (use a hair dryer to speed up the process), use a damp brush to apply acrylic pastel ground evenly throughout the surface, covering every area, including the white space. Let dry.

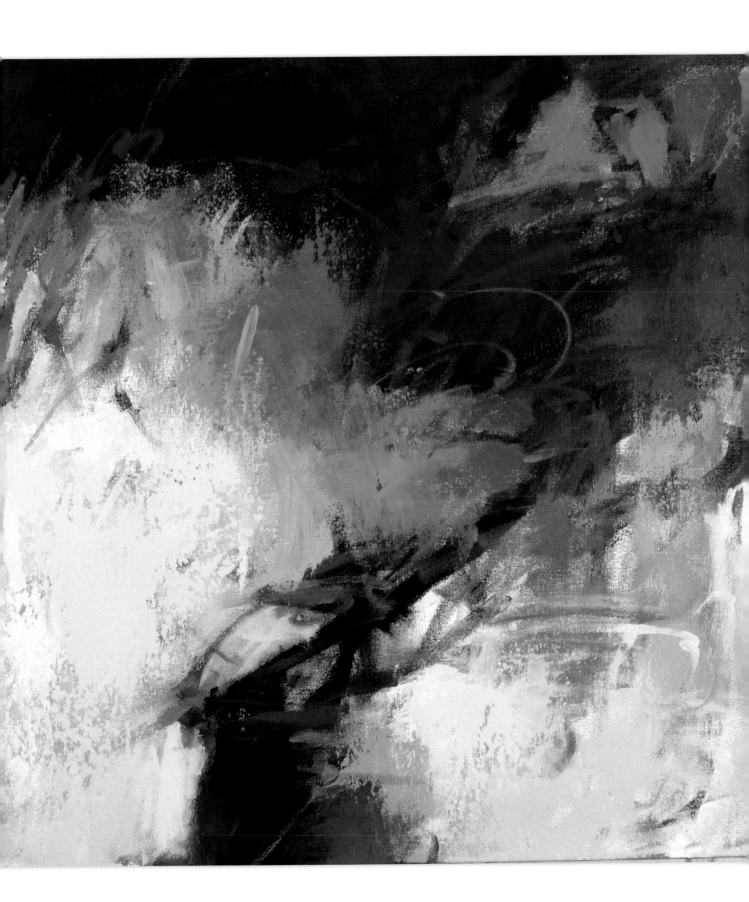

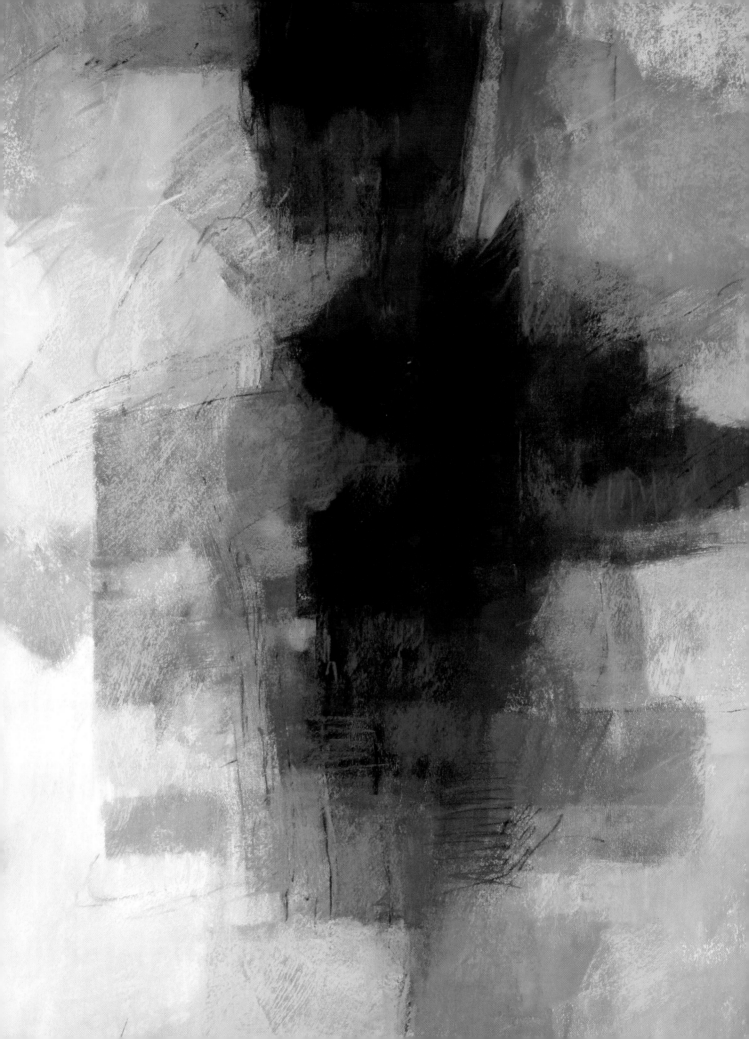

Working WITH
Color AND Value

Abstract art is the result of an attempt to make pictures more real, an attempt to come nearer to the essence of painting.

—ROGER HILTON

Color is exciting. How do you go about choosing which colors to use for a painting? Do you find yourself using too many colors? Is it hard to know what color to use next? When you look at your painting, is something lacking? Do you get confused when you think about color?

I found color very challenging until I began working with pastels. Pastels opened up an entirely new world of color for me. I no longer had to mix paints but chose from the array of pastels in my collection. Then began the challenge of knowing which colors to use, and there was a long period of trial and error. I often found myself thinking back to my early college days when I first learned about complementary colors.

Color is challenging. Oftentimes too many colors are used. Sometimes not much thought goes into color choices. The wrong values of color are used, leading to a painting that does not have much dimension. Neutrals or earth tones are ignored, and too many bright colors are chosen. Color is important and not as simple as it may seem. There is always more to learn about color.

In this chapter I will share some things I have learned about color through my own process. I will give you some basic color combinations. I also encourage you to make color studies a part of your practice.

Color Choices

FOCUS ON COMPLEMENTARY COLORS

When planning a painting, try to focus on the complementary colors. Use red and green as an example. You are working on a pastel painting with the primary complements of red and green. In any painting, red is more dominant than green. Within each of these colors, there are also variations. Don't choose one red or one green. Look for variations in both colors. For red, choose red-violet, red-earth or red-orange. In green, look for yellow-green, blue-green and green-earth. These varieties in the color combination of red and green will make your work more interesting. What happens when you mix red and green together? You will find neutrals of each color in this way. You will also choose different values of red and green. Some colors will be light and some dark. I will talk more about neutrals and values later.

The same is true for painting in acrylic. You also have a red and green complementary color scheme. To achieve more variety in colors choose different hues of red and green. You may choose Red Oxide, Cadmium Red or Magenta. For green, you might choose Viridian, Oxide Green or Yellow Green. You do not have only one hue of green or red but variations. You create neutrals of these colors by mixing both red and green together. You can also create a variety of values by mixing tints and shades of both colors.

I have found that working with one medium enhances the other. Mixing paints has helped me learn more about identifying neutrals in pastels. Choosing pastels for a pastel work has helped me know which color to use in an acrylic painting. Sometimes when working on an acrylic painting, I am stumped with where to go next. I imagine the work as a large pastel instead of a painting and ask myself what color I should use next. I look at my pastel collection, choose the color and hold it up to my painting. Then the challenge is how to mix the color. Both mediums complement the other in this way.

THE COLOR WHEEL

Do not underestimate the value of using a color wheel. A color wheel will help you focus on color combinations. It will also help you identify other colors you may have overlooked. On the pages that follow, I have listed some various color schemes often displayed on color wheels.

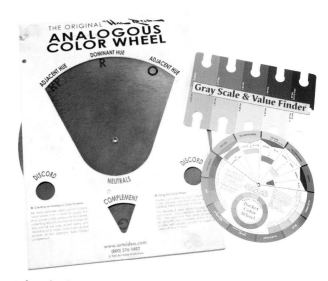

Color wheels, gray values

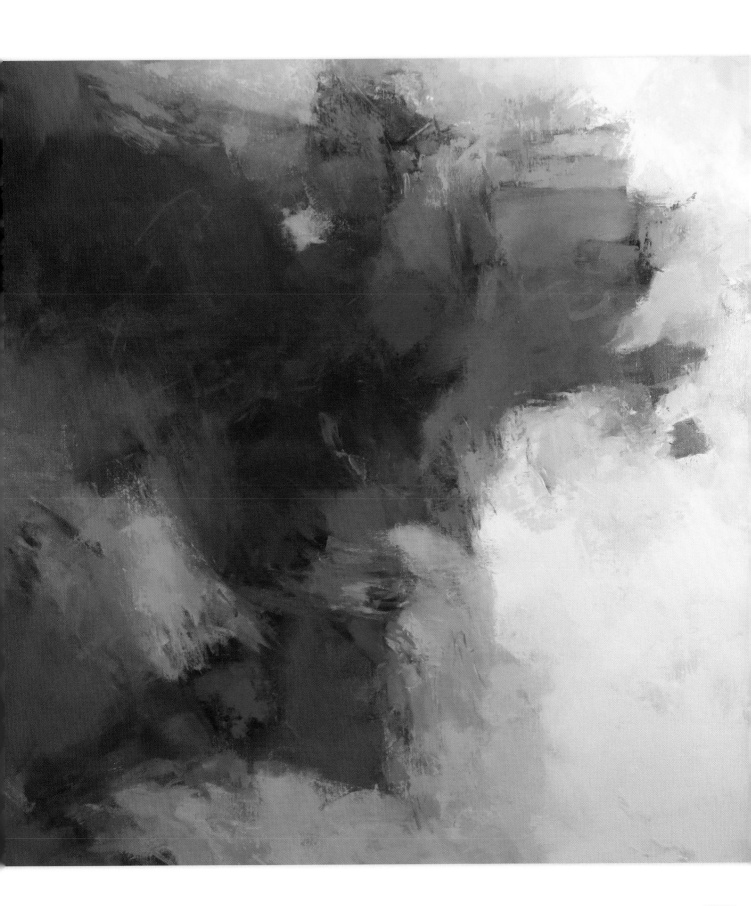

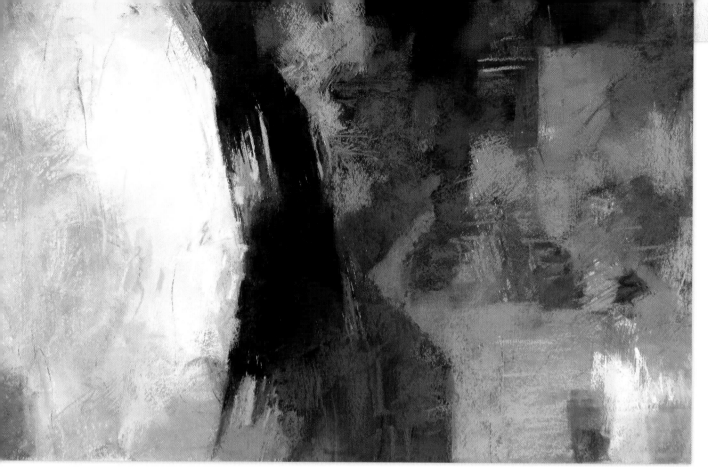

Monochromatic color scheme: pastel painting

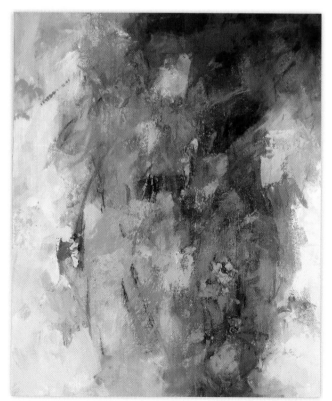

Analogous color scheme: painting

Monochromatic
A monochromatic color scheme is using one color plus its tints and shades. Limiting yourself to one color can be helpful in working with value. Try creating a painting in monochromatic colors.

Analogous
Analogous colors are colors beside each other on the color wheel, such as yellow-green, green, blue-green and their variations.

Complementary
These colors are opposite each other on the color wheel. Red and green, violet and yellow, blue and orange are examples of complementary colors.

Split- or near-complementary
In this combination you have a main hue such as yellow and two hues on either side of the complementary such as blue and red-violet.

Primary and secondary triads
This combination includes any three colors on the color wheel with a balanced triangular relationship. Yellow, red and blue or orange, green and violet are examples of these triads.

Tertiary triads

Three tertiary colors like red-orange, yellow-green and blue-violet make up this combination. Another tertiary triad would be red-violet, yellow-orange and blue-green.

Complementary triads

This combination includes two complementary colors and the third color that comes between them such as orange, blue and yellow.

Modified triads

This triadic combination includes three nearly analogous colors with one space between them.

Adjacent complementary tetrad

This combination includes four colors with a rectangular or square relationship on the color wheel.

Cross-complementary tetrad

This combination includes a pair of complementary colors, then the complementary pairs midway between them. Use one pair as the dominant combination and the other two as accents and support.

Split-complementary tetrad

Choose two colors, skipping one space between them, on the color wheel. The complements of these two colors are the other two colors in the tetrad. Use two as the dominant and the other two for accents and neutralizers.

Analogous complementary

Three neighboring colors and one or two of their complements comprise this kind of combination.

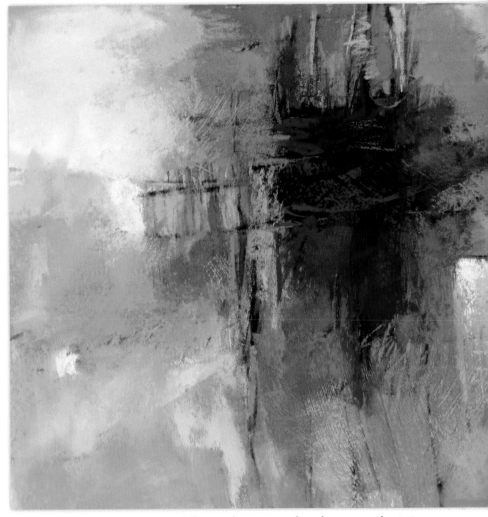

Split complementary color scheme: pastel painting

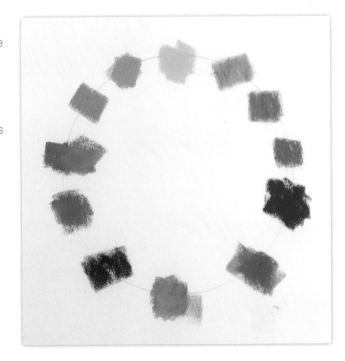

Bringing Value to Your Work

THINK ABOUT VALUE

It is important to think about value when using color. If all colors are of the same value, they are all fighting for equal attention. You will struggle to have a focal point if all colors are of equal value. You need to think of light, medium and dark when choosing your colors.

When I am painting a pastel painting, I first think of the primary complementary colors in my painting. I then go to my pastels box and choose lights, mediums and darks of the colors I will use. I lay them out in order on a table next to my painting. When I do this, I am limiting my color choices and focusing on value. I can go back in and choose some other colors to add emphasis later on. It is important in the beginning to think of value and complements.

In an acrylic painting, I do much the same. I have three palettes and I mix light tints on one. I put my white and Titanium Buff by this palette. I have a palette for cool colors and one for warm colors. I lay all the colors in my color scheme by the corresponding palette.

Another thing that will help you focus on values of color is your underpainting—a very important part of the beginning stages of a work. Spending more time developing value in your underpainting will help you in choosing or mixing the corresponding value of color. If the area of your underpainting is dark, you know you will choose a darker pastel or mix a darker paint for this area.

Value creates impact in a painting. Some contemporary artists may want very little change in value, and it is a conscious choice for their work. Some may work in a very limited color range. There are exceptions to every rule or thought when it comes to abstraction. I prefer works with impact and a certain amount of drama. Value is important to achieve this. The works I am drawn to are the works that make an immediate impression on me. They are usually works with a lot of contrasting values. You may choose another direction.

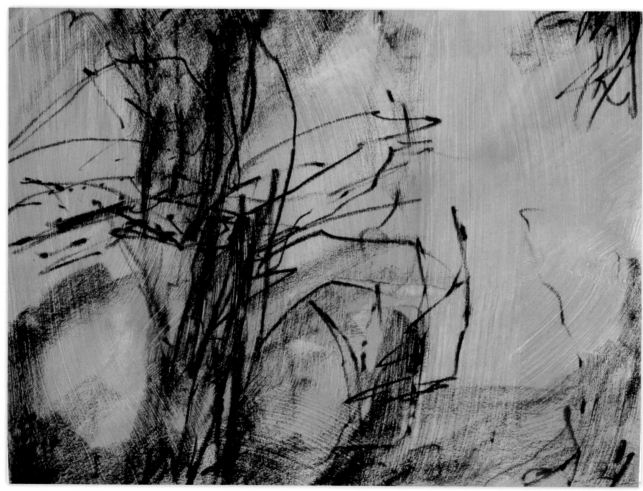

Value drawing on tone paper

Pastels based on values

DON'T FORGET NEUTRALS

Do not forget the importance of neutrals in your color choices. Neutrals are earth colors and grays in your complementary color scheme. There are many variations of these colors.

It may be easier to understand these in painting. When you mix orange and blue together in different combinations, you will get a less intense version of both colors. You will get the neutral, gray or brown of the color. These colors are very important because they give more energy to the pure color.

Too many pure, brilliant colors fight for attention and can look garish. Those same colors look much different if you surround them with neutral colors. You may have an area of blue-gray in your pastel painting, and then you add a touch of yellow-orange. That yellow-orange sings next to the blue-gray. The neutral helps bring out the vibrancy of the color. Adding the same yellow-orange alongside Ultramarine Blue would not have the same effect. They would both fight for equal attention.

mix. paints TO learn about neutrals

Learning to use neutrals can be challenging. Mix paints to learn more about neutrals and all the variations you can achieve. One year I took cheap tempera paints and explored neutrals because I knew I was not choosing enough neutral colors in my pastel paintings. I chose two colors like red-violet and yellow-green. I mixed many combinations of the two and found so many beautiful variations. I took these small exercises to my pastel collection to look for corresponding colors. This really helped me identify some wonderful neutral colors that I had ignored.

95

Color Study with Acrylic

I often create color studies before I start a larger work. You can create a small color study on canvas paper or small stretched canvas or even heavy paper. Use the same colors and composition for your larger painting. Color studies help you practice brushstrokes, color mixing and application. You can test colors out to see how they appear together in a color study. This example shows a primarily red and green complementary color scheme.

What You Need

- acrylic paints:
 - Cadmium Orange
 - Cadmium Red
 - Cadmium Yellow
 - Oxide Green
 - Titan Buff
 - Viridian
- color shapers
- canvas paper, small canvas or heavy paper with a red underpainting
- paintbrushes for acrylic
- palette
- palette knives or other tools

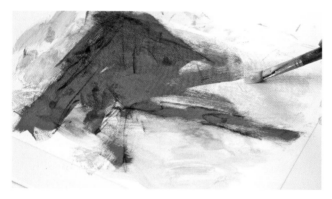

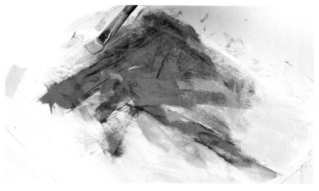

1 Use a surface that has been prepared with an underpainting of red gesso or fluid acrylic. Apply a color like Titanium Buff in areas of lightest values. This helps you determine the light and dark of your composition.

2 Choose a complementary color like Oxide Green and lighten with white or buff. Add this to lighter areas of the composition.

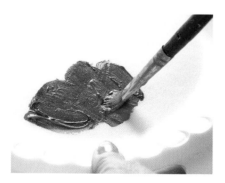

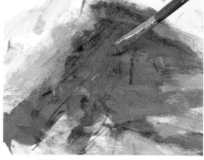

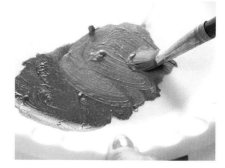

3 Add a little Oxide Green to the red to darken.

4 Add this darkened red to the red areas in the painting. Use random brushstrokes throughout the red section of the painting.

5 Mix in some dark orange with your red to create a warmer version of red.

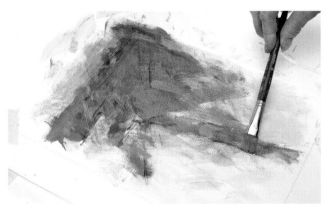

6 Add the warmer red to sections of the red shape in the painting. Use small brushes, color shapers or palette knives to add a variety of mark making.

7 Mix additional versions of your red and green color combination. Try adding Cadmium Yellow to the red or green. Use Cadmium Orange or Cadmium Red.

8 Apply paint with a palette knife across the canvas. Use other tools to apply paint for a variety of textures and mark making.

9 Create lines and marks in your painting with a tool like a pointed color shaper or other implement. Apply with a palette knife across the canvas to add additional texture to the painting.

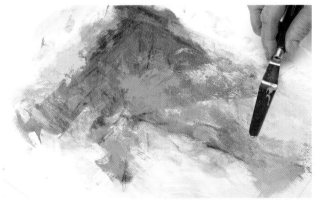

10 Use the colors in your painting to create lighter values. Use a different green like Viridian to create a lighter version of green. Mix the Viridian with Titan Buff and/or white to create light green.

11 Use a palette knife or other tool to add light color to the lightest area of your painting. Set your painting aside and evaluate later.

Color Studies with Pastel

Create small color studies in pastel to test composition and color scheme. This will help you work things out before painting on a larger sheet of paper. Small studies also help simplify elements of the composition and then can be used as a guide in your larger work. You should not try to copy it exactly but use it only as a reference. Small works are often easier to simplify and keep expressive than larger works. The goal is to bring the same freshness to a larger work.

STUDY ONE

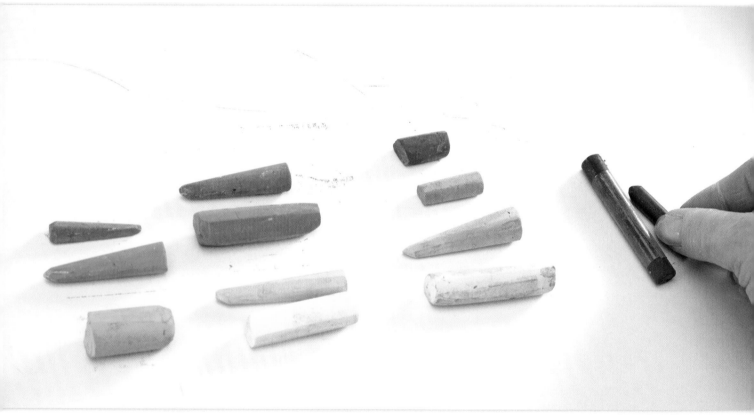

Lay out your pastels in order of value, light to dark. Make sure to have an arrangement of colors that complement one another.

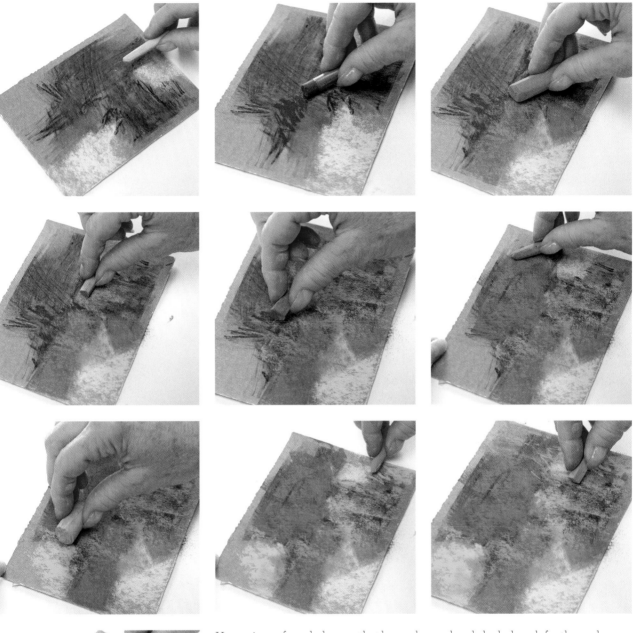

Use a piece of sanded paper that has a charcoal and alcohol wash for the under-painting. Look for the dark and light values in this underpainting. Enhance the lightest areas with a light-colored hard pastel stick.

Apply some neutral colors in both light and dark areas. Neutral colors will balance the stronger colors in your color scheme. Use the original charcoal wash as a guide in applying pastels. Follow lines created by the brushstrokes in your underpainting.

Continue applying pastels throughout the small color study. Apply lightly in the beginning. This will help you build up layers as you work. Use both the side and the tip of the pastel in your application.

Go back over the entire small color study and enhance areas with additional lines in hard and soft pastel.

STUDY TWO

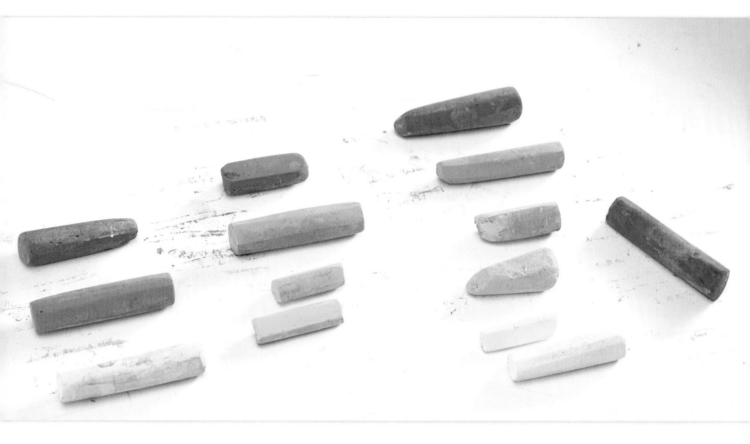

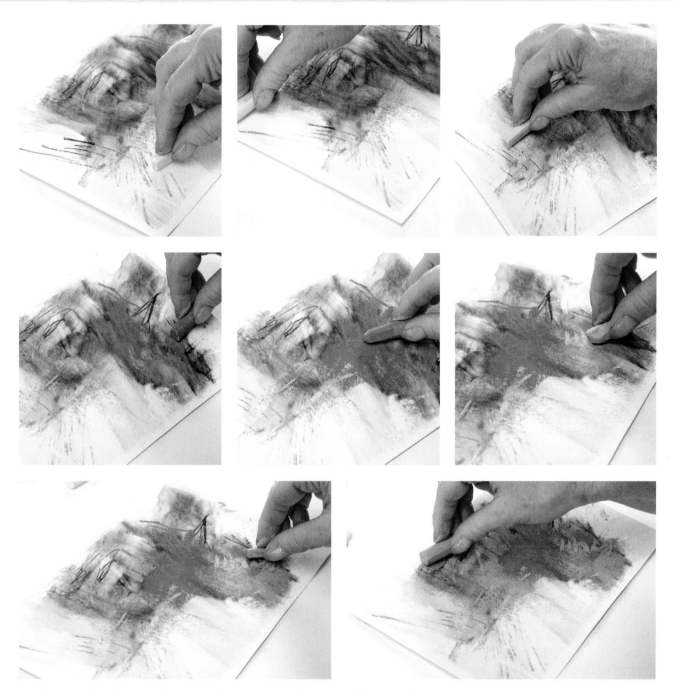

For this second study, again, let your underpainting guide your pastel mark making. Work in layers, applying hard pastels first and soft pastels more toward the end. Remember to work with the sides as well as the tips of the pastels. Look for the light and dark areas of your underpainting and add color accordingly, balancing your color application. Apply neutral colors as well as brilliant colors.

Lines can be enhanced using the tips of the pastels—soft as well as hard.

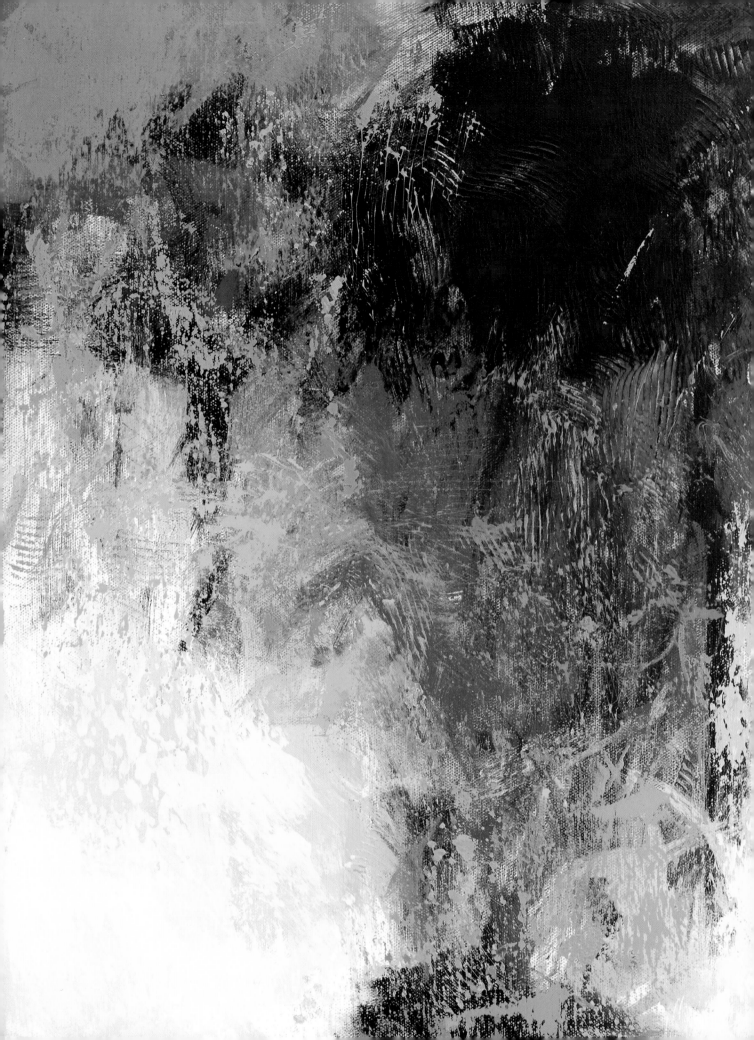

CREATING
Complete
Works

" Abstract literally means to draw from
or separate. In this sense every artist is
abstract . . . a realistic or nonobjective
approach makes no difference. The
result is what counts.
—RICHARD DIEBENKORN

You have created small sketches and studies and now want to
move on to larger works. You approach a larger work much
the same way as a smaller one. The smaller works will be of
benefit to you as you begin to work larger. Your planning and
initial process will be very similar whether you are creating a
pastel or an acrylic painting. You can begin both in the same
way but on different surfaces. You may want to work your way
up in size of paper or canvas. Initially you may want to increase
the size of the work to 12" or 20" (31cm or 51cm) until you feel
comfortable with working larger.

Begin your work with the small thumbnail sketches and
color studies you have created. These will give your larger
works direction and assist you in keeping a large work from
getting overly complicated. Smaller works help you work
out the underlying structure, color scheme, the color of your
underpainting and the value within your work. I find I am more
successful if a few small works precede a larger piece whether
it is pastel or acrylic painting. The smaller pieces give me an
opportunity to warm up.

Tips for Creating Acrylic Paintings

Here are some of the steps in creating a larger acrylic painting. You will want to experiment with different surfaces to find which one best suits your style of working. You will incorporate underpaintings, drawing, grounds and gels and a variety of tools for applying paint.

SURFACE

Choose the size and surface you will work on; canvas is only one option. You might also choose canvas panels, hard board, cradled boards or prepared paper. I will refer to canvas in this section, but my information can be applied to working on other surfaces. Consider shape, also: square, rectangle, horizontal or vertical orientation.

ADDING TEXTURE

Adding texture can come at different times during the painting process. You can use a variety of molding pastes or gels to build additional texture to sections of your canvas. You can tint the pastes or gels with paints. You can take different materials and scrape into the paste to add texture. Pastes and gels need to dry overnight before beginning to paint over them.

DRAWING

In the beginning stages, when you're using your thumbnail sketches as a reference, draw with materials such as compressed charcoal sticks, vine charcoal, hard pastels or graphite sticks. I often go over these materials with acrylic gels, rubbing alcohol or pastel ground. Drawing also creates a painting with a variety of layers.

UNDERPAINTING

For this stage, you can use fluid acrylics, regular acrylics thinned with water or medium or colored gesso. Underpaintings will help you develop structure, composition and value.

Use one or two colors loosely to reflect your initial sketch or color study. You can add value to the underpainting through the use of charcoal or black gesso. Keep this part of the process simple—no details needed.

MIXING PAINTS

Use three different disposable palettes: one for light colors, one for cool and one for warm. Mix your light, medium and dark colors along with neutrals. I enjoy mixing paints, but sometimes choosing pastels from my collection is much easier. If I am stuck on what color to use for an acrylic painting, I often go to my pastel box and look for the color I might use if it were a pastel painting. I hold it up to the canvas to see if it is right, or I might even make a mark with it on the canvas. I then refer to a color wheel or a book on color mixing. It is best to use a palette knife when mixing instead of a brush.

COLOR SCHEME

Choose your main color and its complement as your primary color scheme. Use these two colors to mix neutral colors for your painting. Let's say I'm going to paint a yellow and violet painting. Yellow may be my main color and violet is its complement. I can use both colors to create neutrals if I mix one with the other in different combinations. You may also want to add a few colors for added interest. In the yellow and violet combination, I could use yellow-orange or yellow-green in certain areas. I might also add a little red-violet here or there. I am a believer in using the color wheel to help me think of colors I might have overlooked.

Work from thin to thick. Develop your painting in layers from thin washes to thick application. Work from broad areas to smaller areas. Apply paint with wider brushes first and in broad areas. You can go back in with smaller brushes or knives and add detail in later stages. Paint lightly and thinly in the beginning, and apply heavier paint toward the end.

BRUSHES AND TOOLS

Consider a variety of brushes and tools: large brushes, large palette knives, color shapers, small brushes, brayers and sponge brushes. Experiment and look around to find other things you might be able to use. Use larger brushes when you work on larger canvases. Using a long-handled brush helps you step away from the canvas and make larger movements with your arm. Larger brushes with long handles can help you work more expressively.

Tips for Creating Pastel Paintings

Pastel artists today are so fortunate to have a wide variety of supports available for pastel painting. There are so many possibilities for combining surface, texture and underpainting in pastel work. You will discover through experimentation the best fit for your style. The following tips can assist you when approaching your pastel painting.

SURFACE

You'll probably want to experiment with several surfaces to find the one that is right for your style. Surface does influence the outcome of the final work. Some surfaces are smoother and will not give as much texture as others.

Will you work on sanded paper such as UART or Wallis? Will you create your own sanded surface by using pastel ground on paper? Will you work on canvas or board for a painting surface? All of these materials have their own characteristics.

UNDERPAINTING

If you're using an underpainting, you will need to decide if it will influence the color of your painting. Will you use a blue under-painting for a blue abstraction? Or, will you use the comple-mentary color underneath? Will you have a red underpainting and allow some of it to show through a yellow-green work?

I discussed the different ways you can create underpaint-ings in a previous chapter. I have found if I spend more time working things out at this stage, my final painting can be more successful.

PASTEL GROUND

If you are going to use pastel ground, you can do so after applying the underpainting. Maybe you have added the acrylic paints to your ground already. Acrylic paints with ground can be your underpainting itself. You can use pastel ground either way.

COLOR SCHEME

Choose the colors for your work before you begin. Go through your pastel collection and choose a selection of pastels based on value. If you are creating a violet and yellow color scheme, choose your pastels based on this combination. Choose values of yellow pastels from light to dark. Lay them by your painting and do the same for violet. You will want to have a value range of pastels to use. Refer to your color wheel for other possible colors that will add impact. Choose some neutrals of either color also. Do not forget that neutrals are very important to a painting whether it is pastel or acrylic. Neutral colors bring harmony to a painting and add impact to your brighter colors.

APPLYING PASTEL

After you have applied your underpainting, you can begin to add hard and soft pastel to your work. You can begin to add hard pastel and then finish with soft pastel. Hard pastel will give you your initial color. You can also create lines and texture with the hard pastel. Don't apply with a heavy hand in the beginning of your work, or you will lessen your ability to create layers of pastel.

Apply pastel lightly at first in order to develop layers as you progress through your painting. Don't apply pastel to one area but work the entire painting. It is a direct application of pigment to the surface and should be used like paint. Don't "color" with pastel. Paint with it!

Apply with the side for broad strokes and with the tip for linear work. Vary your strokes to create movement and texture. I rarely blend pastel with my fingers as I love the velvety richness of pure pastel application. If you apply pastel lightly enough, you can develop several layers of it. This is the ultimate in combining drawing and painting. I learned early in college to apply oil paint thick over thin. I think the same way about pastel.

Begin to use the softer pastels and work lightly so you can add layers. Look for the point of emphasis in your painting. How can you emphasize this area? You can create emphasis by mark making, adding touches of pure color or comple-mentary color, lightening the area or intensifying the colors in the area of emphasis.

Photograph your work as you proceed. Look at your paint-ing through the viewfinder. Upload the photo to your computer and look at it. Change it from color to gray scale to see if there is variance in value. You will see it in a different way and be able to assess your work.

Acrylic Painting Demonstration

You have completed a small study and are now ready to work on a larger painting. Acrylics and many pastels work very well together. You can combine materials for a mixed-media painting. Use charcoal and alcohol wash to draw directly on the canvas as you would for a pastel painting, Use hard pastels to create lines on canvas. You can also use pastel ground to create a gritty surface that will make it easier to draw on canvas. Build up the surface of your painting and develop more texture with molding paste. Use colored gesso and fluid acrylics to begin your work and create a more developed underpainting. Experiment with painting to find what works for you. If you don't like what you have painted you can always paint over it!

What You Need

- canvas, 20" × 20" (51cm × 51cm)
- colored gesso, red and black
- compressed charcoal
- fluid acrylic
 - Vat Orange
- hard pastels
- molding paste (Golden)
- matte medium (Golden)
- paintbrushes, assorted
- palette knives
- soft body acrylics:
 - Burnt Sienna
 - Cadmium Red
 - Cadmium Yellow
 - Chromium Oxide Green
 - Light Green
 - Pyrrole Ogange
 - Red Oxide
 - Titan Buff
 - Ultramarine Blue
 - white
 - Yellow Oxide
- reference sketch
- tools to add texture

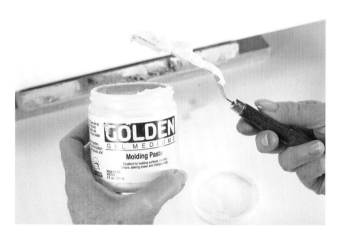

1 Using a palette knife, scoop out some molding paste.

2 Apply the paste to the canvas in several areas to begin creating texture.

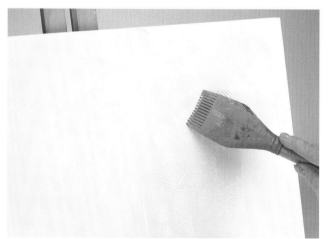

3 Use a tool to add additional texture to the paste. The textured canvas will add surface interest to your completed painting. Allow the paste to dry overnight.

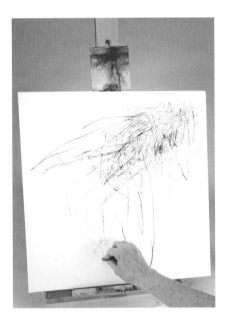

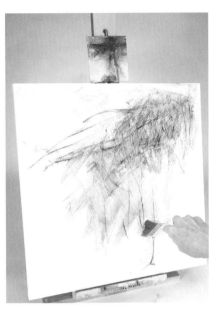

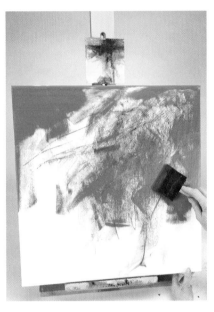

4 Use the thumbnail reference sketch as a guide to draw on the canvas using compressed charcoal and hard pastel. Lines will influence the successive paint layers of your painting.

5 Apply matte medium over the charcoal and pastel with a wide brush. This will fix the drawing onto the canvas. While you will eventually paint over these lines, you can allow some to show through the finished painting.

6 Apply red gesso or fluid acrylic to create more of an underpainting. Cover the edges of the canvas at the same time with a corresponding color. Use a sponge brush or a paintbrush.

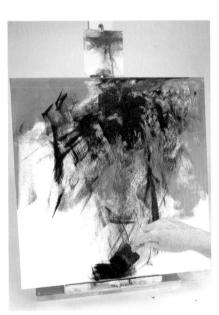

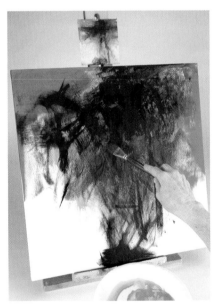

7 Use black gesso to create additional dark values in your underpainting. Here black gesso is used over the red. Tip: Applying gesso allows you to outline an underlying structure, which you can later use as a reference for light and dark areas while you are painting.

8 Apply washes of color to the underpainting. You are working and developing layers in this approach. Vat Orange is used to further develop intensity and strength of color.

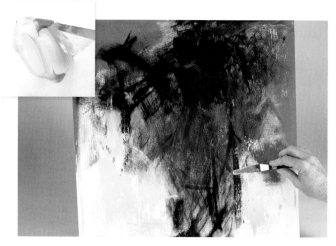

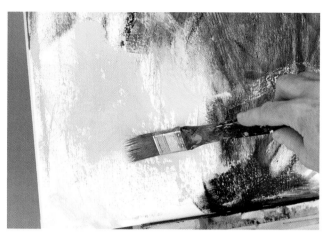

9 Mix Titan Buff and Yellow Oxide to make the colors warmer. This mixed color is a great alternative to the color white.

Apply the paint with the palette knife in random areas around your canvas. Allow the palette knife to leave textured impressions across the canvas.

10 Take a wide brush and swipe it across the canvas to mix and move the paint around.

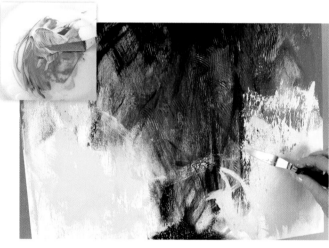

11 Mix Chromium Oxide Green with Titan Buff. Use a palette knife to spread the mix lightly across your canvas, keeping away from the darker areas.

12 Use a color shaper or the handle of a paintbrush to make lines on your canvas with the green mixture.

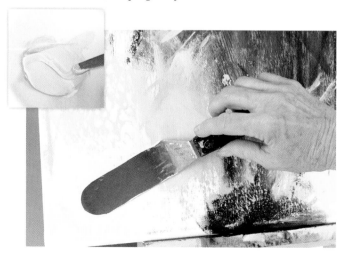

13 Mix Titan Buff and white, and using a large palette knife, spread it across the lighter areas.

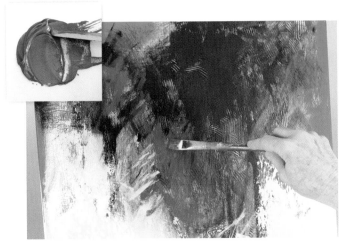

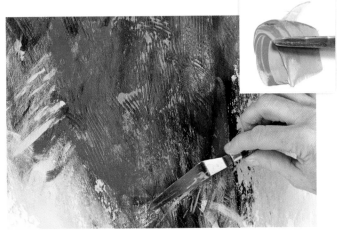

14 Mix Chromium Oxide Green with Red Oxide to create a darker red. Then lightly brush it across the darker areas of your painting using a small paintbrush. Mixing complementary colors in your painting makes things appear more unified.

15 Mix Yellow Oxide and Cadmium Red. Apply the mixture with a palette knife onto your painting. Allow the knife to leave texture in its wake, but don't apply the mixture too thickly.

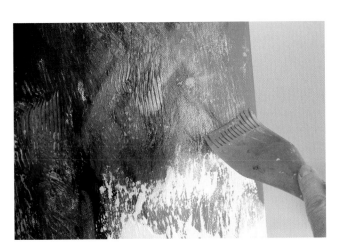

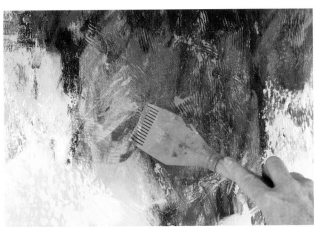

16 Mix Cadmium Red and Cadmium Yellow and apply it to your painting with a textured brush in random sweeps where the darker and lighter areas of the painting merge.

17 Take a small break and stand back from your painting to get a different look at it. This might inspire you to try something different, like using a completely different color.

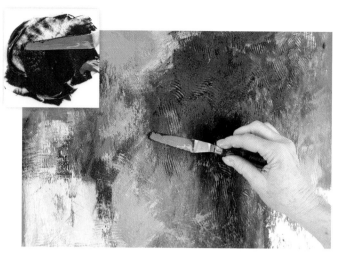

18 Mix Ultramarine Blue and Burnt Sienna to create a darker blue. Apply this mixture lightly to the darkest areas of your painting.

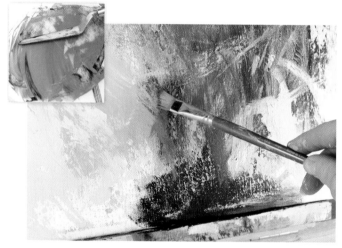

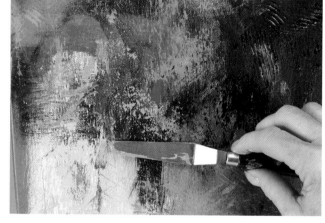

19 Add white to your blue mixture to create a gray color. Apply this gray color with a color shaper or a palette knife across your canvas in random sweeps.

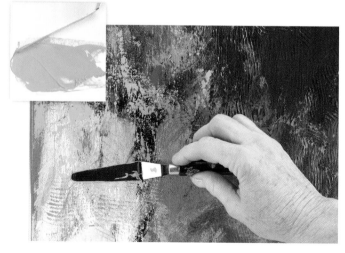

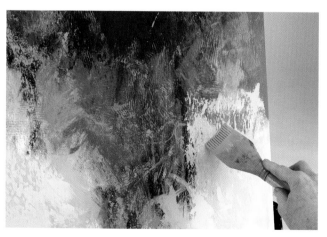

20 Mix Cadmium Yellow and Light Green with your palette knife, then apply to the blue areas of your canvas.

21 Use a texture tool when you apply some of the paint to create linear textures.

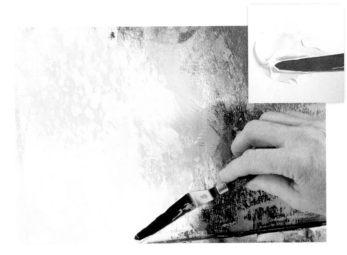

22 Lighten Titan Buff with white to create a neutral light. Add the mixture with a palette knife to create additional texture.

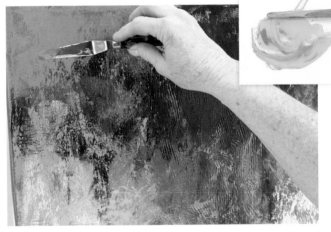

23 Mix Cadmium Yellow with Pyrrole Orange, then use your palette knife and a color shaper to apply lines randomly throughout your canvas.

24 Finish up your painting by painting the edges of the canvas the same color as the top. Try adding a little color variation.

Pastel Painting Demonstration

You can use many of the same materials from acrylic painting for a mixed-media pastel work. Use fluid acrylic to create a dynamic underpainting. The underpainting will help you work more expressively and intuitively. Draw on the underpainting with charcoal and pastel. Add pastel ground to create a unique sanded surface. These materials will allow you a lot of flexibility in your approach to creating a pastel abstraction.

What You Need

- compressed charcoal
- hair dryer (optional)
- fluid acrylic in the color of your choice (Vat Orange is used here)
- masking tape
- paintbrushes, wide
- paper (BFK)
- pastel ground
- soft and hard pastels

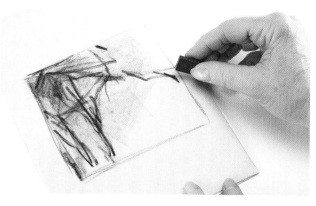

1 Create a charcoal thumbnail sketch for your basic composition. You can add touches of color in the basic color scheme for your pastel painting. This sketch will serve as your guide as you apply underpainting and successive layers of pastel.

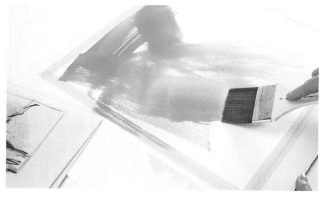

2 Apply a wash of fluid acrylic to your paper with a large brush. Add water to your fluid acrylic to dilute. Apply additional layers of acrylic to the darker areas of your painting, using the thumbnail as your guide. Here I am using Vat Orange as my underpainting.

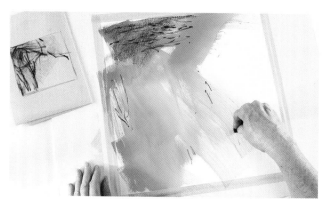

3 Begin to add charcoal lines to your dried underpainting. Use your thumbnail as your guide in applying additional lines to the underpainting. Look for interesting textures and lines created by the brushstrokes. Enhance these areas with charcoal and/or hard pastel.

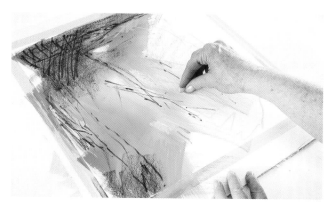

4 Apply additional mark making with hard pastels in the color scheme of your painting. Be expressive with this mark making. Do not focus on detail. Let the underpainting guide your mark making and work intuitively.

5 Apply pastel ground with a wet brush on top of this initial underpainting and mark making. Do not be concerned with smearing the charcoal or pastel at this point. This step will help create more value and additional textural marks. Allow to dry thoroughly. You can speed up the process by using a hair dryer.

6 Begin applying soft pastel to the dried ground. Here I am applying a combination of oranges, violets and greens to random areas of the pastel painting. Try accentuating the darker values by highlighting them with strokes of brighter colors, such as orange. Apply a light color to the lower left-hand corner. I am using lavender.

unifying WITH color placement

Every time I apply a color, I try to apply it in more than one spot on my painting. If I put blue-violet in one corner, I may put it in the opposite corner also. I may put a variation of it elsewhere. This brings unity to the work by moving the color around.

THE underpainting is your GUIDE

Use the underpainting as a guide for where to put your pastels. Your underpainting and initial drawing will be completely covered with pastel by the time you have finished your painting.

7 Choose lighter values of pastel to apply to the lightest areas of your painting. Look for the lightest values of color to include in whites. Include neutrals like earth tones and grays.

8 Work the entire painting with pastel. Break up some of the darker and lighter areas with neutral colors. Bring the whole work together as you apply pastel. Apply brighter pops of color in darker or more neutral areas.

These bright colors will bring emphasis to the area. Here I am blending some of the light areas with the more neutral areas by applying varieties of orange-colored pastels.

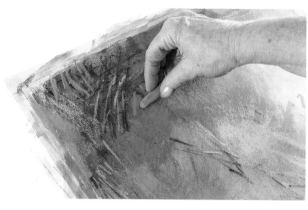

9 Bring variety and subtlety to your work by placing neutrals with more pure colors. These neutrals will include earth tones and grays. Here I am using a dark olive pastel to the dark area of my pastel painting.

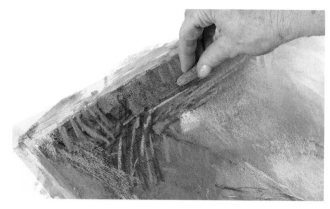

10 Add cool pastels in a warmer area of your painting. Instead of using only one color in a dark area, look for a combination of both warm and cool pastels for this area. Here I am adding a blue-violet to accentuate this darker area. The olive green and blue-violet complement each other in this dark area of the painting.

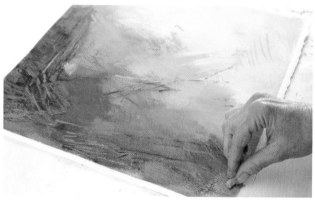

11 The addition of a light complementary color brings added dimension to the primary color of the painting. Here I am applying a light turquoise pastel to the lower right-hand side of the painting.

12 Bring your light areas to conclusion by adding additional light or white pastels. Look for those very light neutrals and white varieties.

13 Bring emphasis to an area of your painting with the lightest values of pastel and/or complementary colors. Add pops of pure color to emphasize an area in your painting.

14 Blend separate areas together by choosing a range of values in pastel. Here I am using a yellow pastel between light and middle values to create a smoother transition.

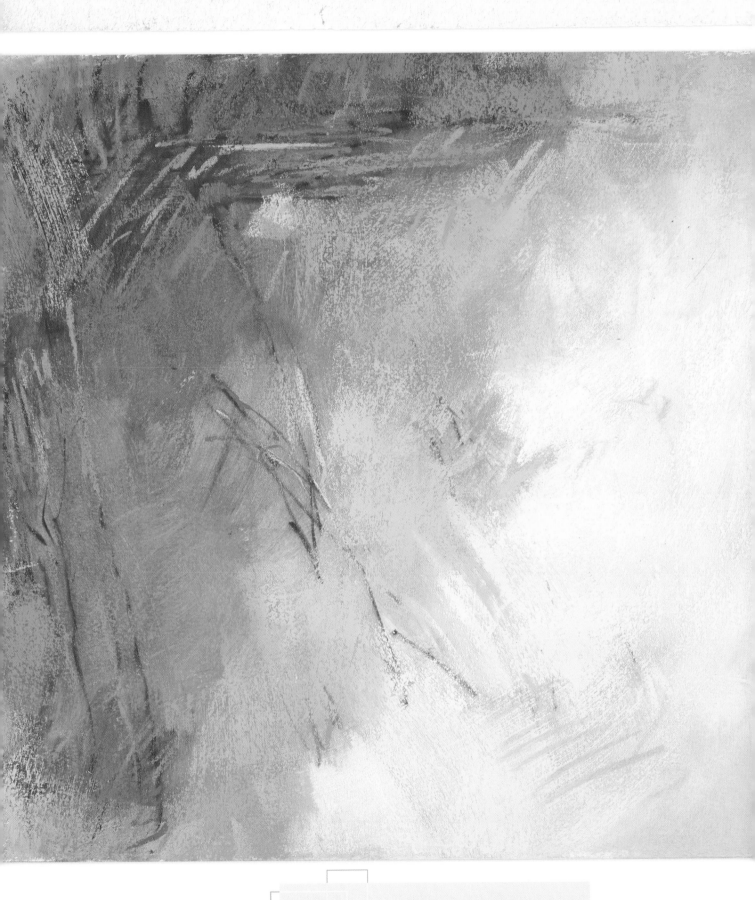

TAKE
breaks
AND
change
perspective

Take a step back from your work. If you get stuck, take a break from your work and come back to it later. Turn it upside down. Look at it in the mirror. Take a photo of it. Try to see it from a different angle.

Horse Painting Demonstration

You can create an abstract realistic work by combining techniques. Combine underpainting and a realistic drawing to create an abstracted realistic version. In this example I have combined underpainting and a drawing of a horse to create an abstract horse pastel painting. You can try this with a variety of subjects. Try combining techniques to create an abstracted still life, figure, animal, flower or landscape.

What You Need

- compressed charcoal
- fluid acrylics, including Cadmium Red
- masking tape
- paintbrushes, assorted
- paper (BFK)
- pastel ground
- rubbing alcohol
- soft and hard pastels

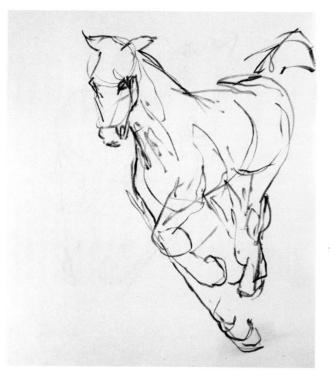

1 Practice drawing your subject like this horse sketch. Sketch loosely and concentrate on movement as in a gesture drawing. Try a variety of different movements and compositions before deciding on the one most suitable for your painting.

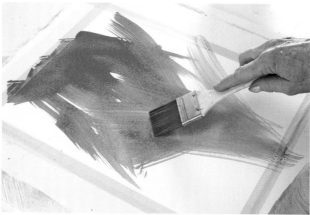

2 Prepare the Rives BFK paper with an underpainting of fluid acrylic. This should resemble the movement of the horse drawing. Apply Cadmium Red acrylic paint to the paper and leave some open areas for interest.

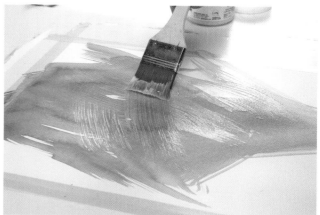

3 Apply pastel ground with a wide brush dipped in water to dilute the ground. Apply loosely to the paper. Strokes of ground do not have to follow any set direction.

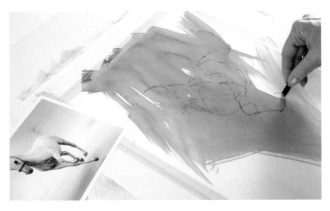

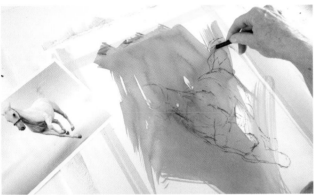

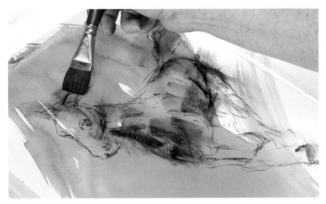

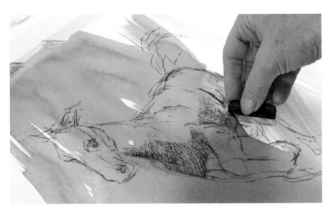

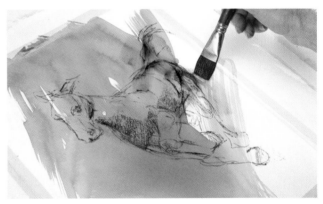

4 Use your preliminary sketch of the horse. Draw with charcoal or hard pastel on the prepared paper. Draw loosely and do not focus on detail. Focus on placement. You can work on details later. Use charcoal to provide some initial shading in the darkest areas of the figure.

5 Create a value wash by applying rubbing alcohol to the charcoal drawing. This will loosen up the drawing even more and will create additional lines and textures you can incorporate into your finished work. The alcohol will also fix the charcoal to the paper.

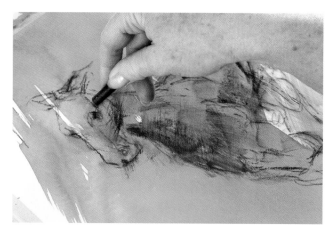

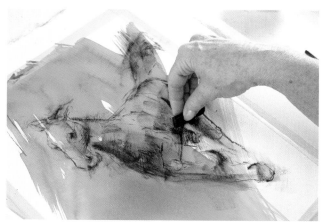

6 Use the lines created by the charcoal and alcohol wash to add expressive mark making. Some lines can create more movement and energy in the drawing.

7 Use your charcoal to increase value around the horse's body. Apply more rubbing alcohol to create deeper shading.

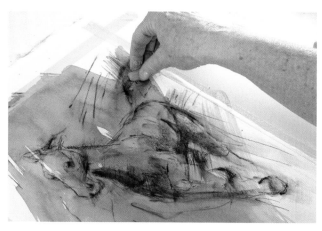

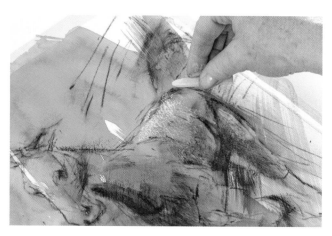

8 Begin to add color to your underpainting of the horse. Choose a range of values in your color scheme. Orange pastel is lightly swept across some of the lighter areas of the horse in this image.

9 To emphasize the lighter values of the horse figure, apply a yellow pastel to the back, head and ears of the horse. You are now delineating the shape of the horse more clearly.

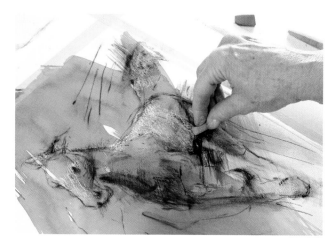

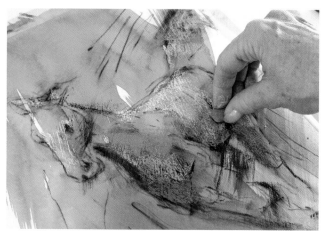

10 Apply a light blue-violet pastel to the darker areas of the horse. You are continuing to bring the figure into focus but are not focusing on details.

11 Continue to deepen the shadowed areas of the figure. Deepen some areas and add highlights to others to bring the figure into focus.

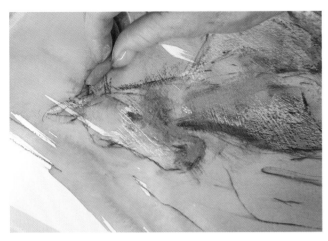

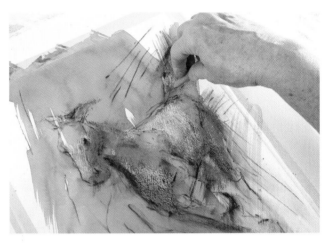

12 Continue adding pastel to areas of the figure to make it stand out from the background. Apply a dark yellow to outline the figure of the horse, but do not trace the entire figure. Find a couple of places to add a lighter value to move the horse forward.

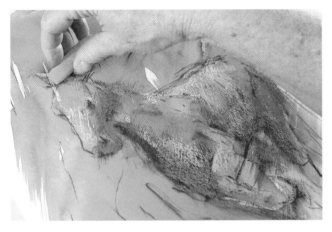

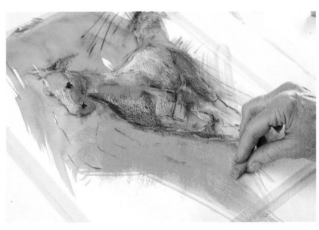

13 Continue working to bring more focus to the figure. Use ligher pastels like orange and yellows to begin filling in the hooves and head area of the horse.

14 Once the horse is nearly complete, begin working on the background of the painting. Apply a light orange pastel onto the lower left background of the painting.

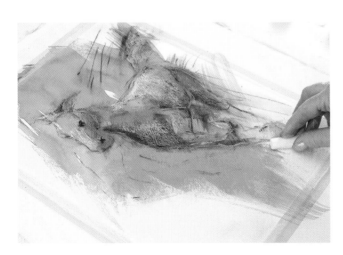

15 Now you will focus on the areas you have left white in your underpainting. Apply yellow pastel to these areas. Make broad sweeps with the pastel to maintain the gestural quality of the painting. This will add to the movement of the painting. In the background, use some of the same colors used in the body of the horse. Use a lighter value of violet in this area.

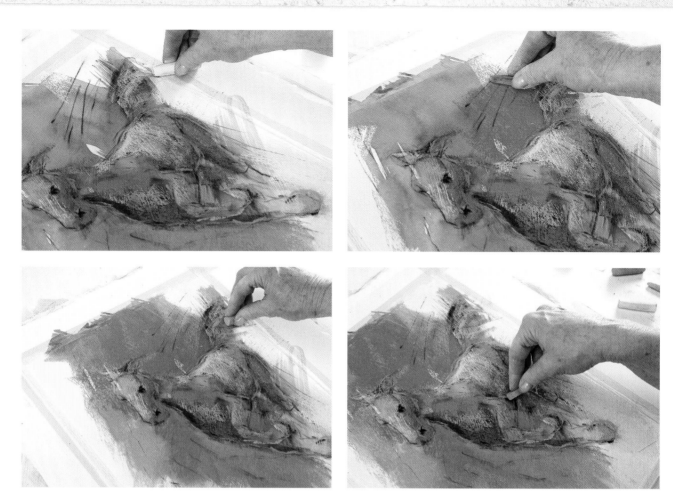

16 Continue to add finishing touches to the background and figure of the horse. Do not focus on detail. Work the entire painting and bring it to a finish.

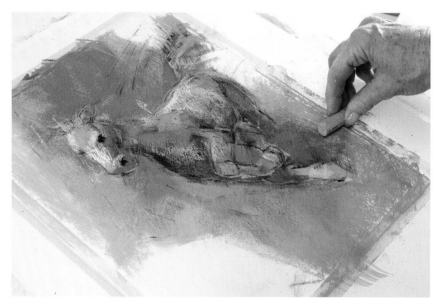

The completed painting has movement because the horse is placed off center. It appears to be moving into the left side of the painting. Not all areas of the horse are clarified, which also adds to the expressiveness of the work.

Have fun with this technique and experiment!

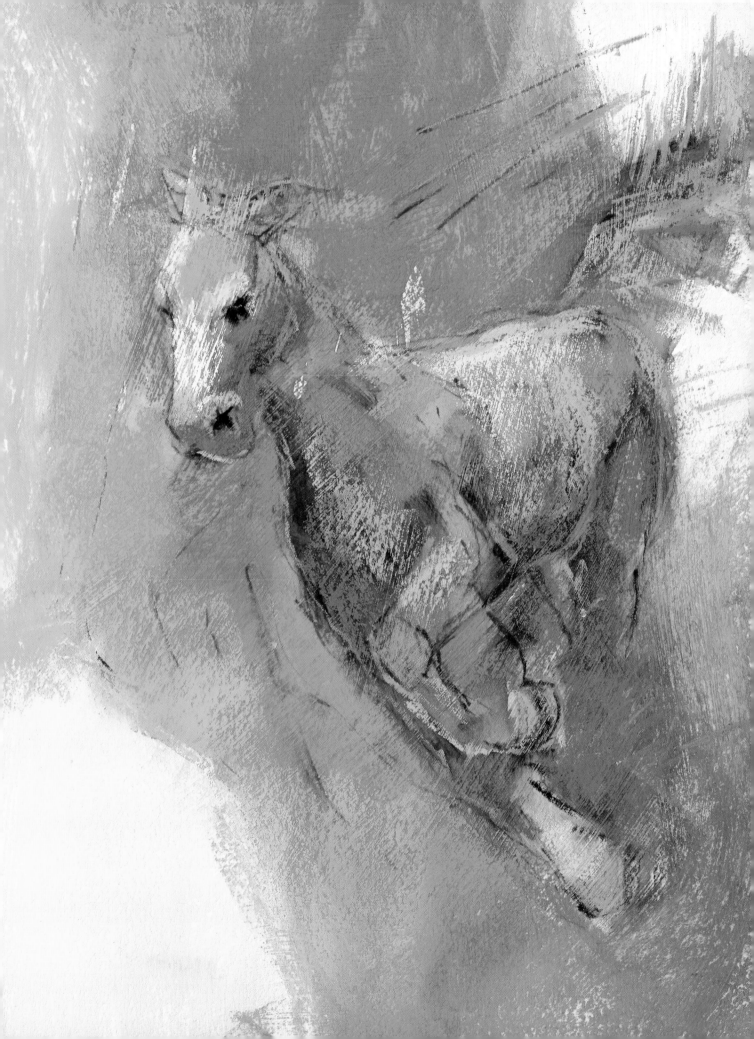

Resources for Further Study

In my workshops I often bring several books for artists to consider. Some are books on the process of abstraction and others are books I have read to help me find my own personal expression.

Trust the Process: An Artist's Guide to Letting Go
by Shaun McNiff

No More Second Hand Art: Awakening the Artist Within
by Peter London

The Artist's Way: A Spiritual Path to Higher Creativity
by Julia Cameron

*Expressive Drawing: A Practical Guide to Freeing
the Artist Within*
by Steven Aimone

The Zen of Seeing: Seeing/Drawing as Meditation
by Frederick Franck

*Drawing on the Artist Within: An Inspirational and
Practical Guide to Increasing Your Creative Powers*
by Betty Edwards

*The Art of Abstract Painting: A Guide to Creativity and
Free Expression*
by Rolina van Vliet

*Art From Intuition: Overcoming Your Fears and Obstacles
to Making Art*
by Dean Nimmer

*Confident Color: An Artist's Guide to Harmony,
Contrast and Unity*
by Nita Leland

Pastel Journal magazine

" Abstract is a frame of mind.
—DEBORA STEWART

Summary

I am using my own quote in this prologue. I worked realistically most of my life and came to abstraction late. It has been a continual process of discovery. I hope to continue to improve and develop my work as long as I am able. I find abstraction both challenging and exciting. Working abstractly has also allowed me to return to realism from a different perspective. I no longer feel stuck and out of ideas.

In my opinion, learning techniques with materials may be the easy part of the process. The more challenging aspect is finding your own vision and voice. Unfortunately or fortunately, there are no short cuts or easy paths. Finding your own style and vision comes through continually working, moving through frustration and discovering what is unique about your perspective.

Being an artist requires much personal reflection. Through personal reflection you come to find what moves you, and you discover more about yourself. Self-awareness is reflected in your art. So much of what we create is really very mysterious. I tend to believe that all of life's experiences are reflected through our art.

I wish you the best as you discover your own personal expression of abstraction.

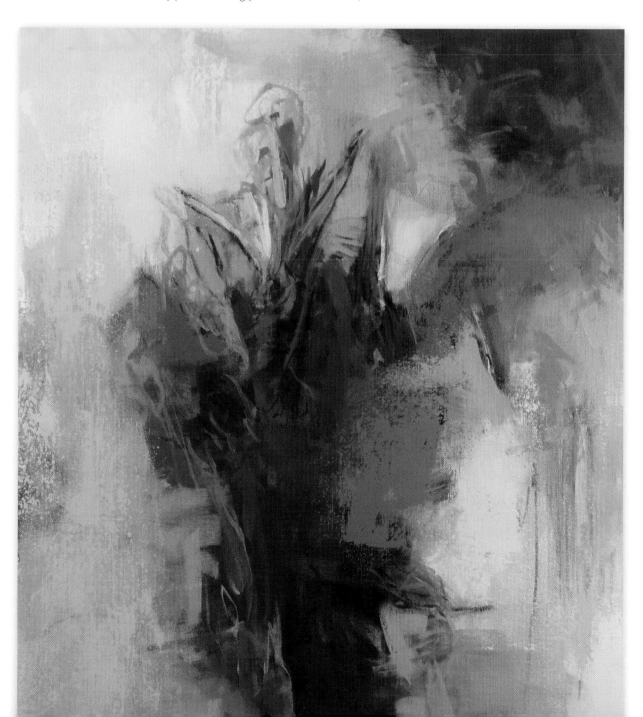

Index

About Debora

Debora L. Stewart is a Signature Member of the Pastel Society of America. She is represented by galleries and design firms throughout the United States. Debora has taught frequently for Artist's Network University and her course in Creating Abstract Pastels has been a popular course. Debora has taught workshops throughout the United States at many venues including the School of the Pastel Society of America in New York City, the International Association of Pastel Societies convention in Albuquerque, New Mexico, and Peninsula School of Art in Door County, Wisconsin. Her work has received awards from *The Pastel Journal* magazine, *International Artist* magazine and the Pastel Society of America.

Most of her life she created art while working full time in human services and education. She is now retired and devoting her time to writing, teaching, painting and traveling. Debora lives in Iowa with her husband, Doug, and her miniature schnauzer, Fiona.

a content + ecommerce company

Other fine North Light Books are available from your favorite bookstore, art supply store or online supplier. Visit our website at fwcommunity.com.

19 18 5

DISTRIBUTED IN THE U.K. AND EUROPE BY F&W MEDIA INTERNATIONAL LTD
Brunel House, Forde Close, Newton Abbot, TQ12 4PU, UK
Tel: (+44) 1626 323200, Fax: (+44) 1626 323319
Email: enquiries@fwmedia.com

ISBN 13: 978-1-4403-3584-6

Metric Conversion Chart

TO CONVERT	TO	MULTIPLY BY
Inches	Centimeters	2.54
Centimeters	Inches	0.4
Feet	Centimeters	30.5
Centimeters	Feet	0.03
Yards	Meters	0.9
Meters	Yards	1.1

EDITED BY Tonia Jenny
DESIGNED BY Hannah Bailey
PRODUCTION COORDINATED BY Mark Griffin